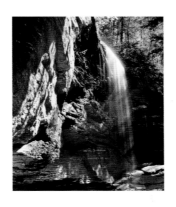

LOCAL TREASURES

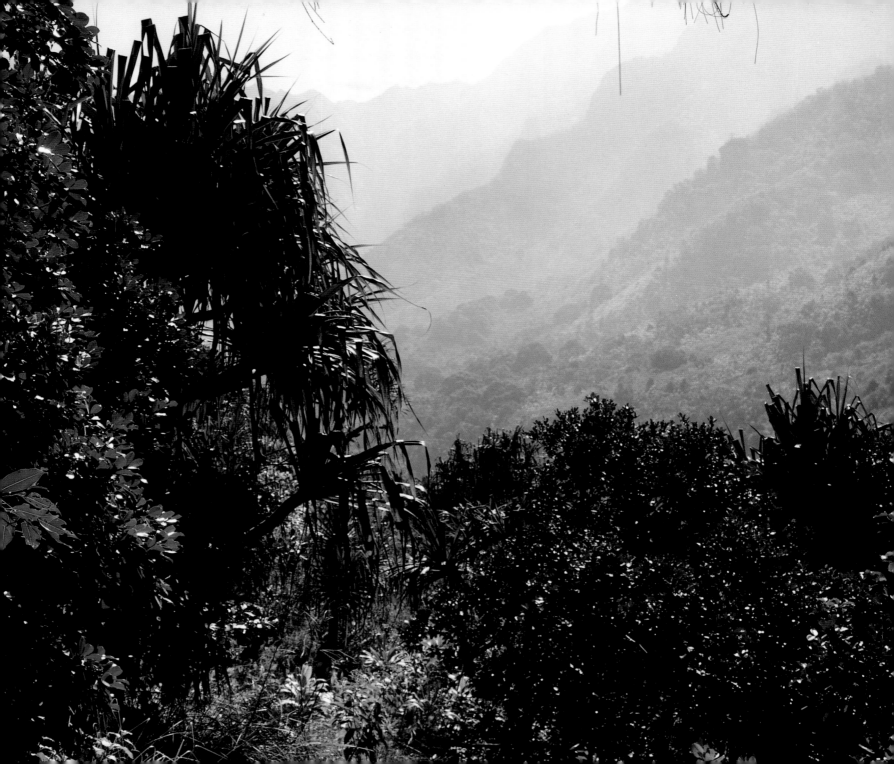

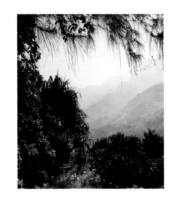

LOCAL TREASURES : GEOCACHING ACROSS AMERICA

Margot Anne Kelley

with a foreword by Frank Gohlke

Center for American Places
Santa Fe, New Mexico,
and Staunton, Virginia

Center Books on American Places
George F. Thompson
Series founder and director

PUBLISHER'S NOTES: *Local Treasures: Geocaching across America* is the fourth volume in the *Center Books on American Places* series, George F. Thompson, series founder and director. The book was issued in a hardcover edition of 2,500 copies, with the generous financial support of the Friends of the Center for American Places. For more information about the Center and the publication of *Local Treasures*, please see page 186.

Center for American Places, Inc.
P. O. Box 23225
Santa Fe, New Mexico 87502, U.S.A.
www.americanplaces.org

Distributed by the University of Chicago Press
www.press.uchicago.edu

9 8 7 6 5 4 3 2 1

Library of Congress Cataloging-in-Publication Data is available from the publisher upon request.
ISBN 1-930066-36-8
Frontispiece: Na Pali Coast, Hawaii, 2004

In my room, the world is beyond my understanding;
But when I walk I see that it consists of three or four hills and a cloud.

—Wallace Stevens, "Of the Surface of Things"

At present, in this vicinity, the best part of the land
is not private property; the landscape is not owned, and
the walker enjoys comparative freedom. But possibly
the day will come when it will be partitioned off . . .
when fences shall be multiplied, and man-traps and
other engines invented to confine men to the *public* road,
and walking over the surface of God's earth shall be construed
to mean trespassing on some gentleman's grounds. To enjoy
a thing exclusively is commonly to exclude yourself from
the true enjoyment of it. Let us improve our opportunities,
then, before the evil days come.

—Henry David Thoreau, "Walking"

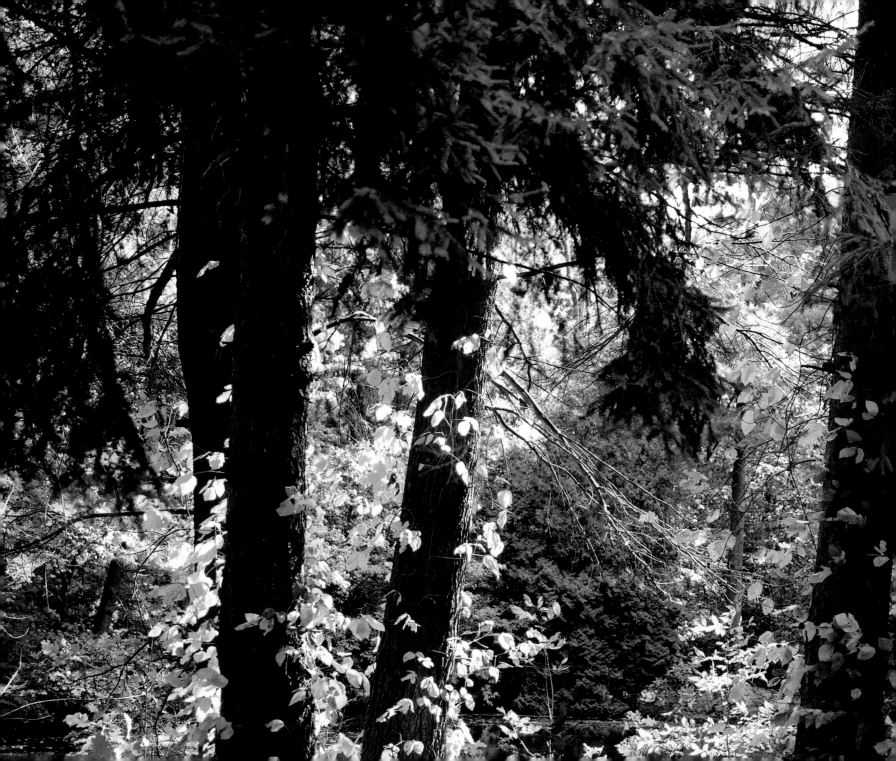

This **book began** with a five-gallon bucket containing a can of beans, two CDs, a topological map of the United States, a cassette recorder, a "George of the Jungle" VHS tape, a book by Ross Perot, four $1 bills, and a slingshot (actually, just the slingshot handle) hidden in the Oregon woods. I've never met Dave Ulmer, the man who put the bucket there on May 3, 2000. Nor have I ever been to those woods or seen the bucket. Nevertheless, when Ulmer put his cache of goodies in the woods and posted the exact latitude and longitude to an Internet chat group, he triggered others—eventually thousands and thousands of others—to do the same. In just a few years, the act of hiding and seek-ing containers of ordinary objects, hidden in public (but unexpected) places, has become the basis for an unprecedented form of community, one that merges some of the most promising elements of the Internet with a desire to enjoy and share locales which range from quirky urban spots to—most often—lovely natural settings.

Dave Ulmer hid the bucket in the woods in order to test whether the repeal of a federal mandate to degrade Global Positioning Satellite (GPS) data had taken effect; he wanted to know how accurate his coordinate readings for latitude and longitude were. So he challenged others who also posted on the newsgroup to see if they could find the hidden box. They could—and they did. Within five months, so many people were hiding and seeking similar containers that the game, which had since been dubbed *geocaching*, warranted an official Website (www.geocaching.com) where players could contribute to a unified database of all the caches.

When I heard about geocaching, in February 2002, more than 17,000 geocaches had been hidden on public lands all over the world. I was curious about what made the game so captivating to peo-ple, about why they would hide so many caches in such a short time. I went to the Website where I

discovered that people seem to hide these boxes in favorite places, inviting others to come and find the geocache while having a nice hike. That made sense to me; I have often shared especially beautiful walking and hiking spots with friends. Geocaching created a huge network of people who were doing so while treasure hunting at the same time. But as I headed to the sporting goods store to purchase a GPS so I could join in the fun, I could tell there was something more to it. Geocaching felt weighty, charged with implications. I wanted to figure out its import.

I have been geocaching ever since. I've visited many cache sites near home, of course, and when I go on vacations or trips for work I try to make time to geocache. In doing so, I've explored places I never would have known about otherwise—true local treasures, tiny parks that tourists would never hear about or parts of well-known places that are still off the beaten path. And I've had the opportunity to participate in an extraordinary experiment in community. Geocaching as an activity and the geocaching community as a social grouping are uniquely of the present moment: both tied to the land and reliant on the Internet. Moreover, this community offers insights into what might come in the near future as people struggle to live well in both the physical and virtual worlds. These and other observations about geocaching as a significant cultural activity are proffered in the concluding essay (pages 137–174).

The physical explorations that geocaching makes possible, the wanderings of body as well as mind, are recorded in the photographs and accompanying stories in Parts I through IV. The stories are like geocaching forays, little trips that sometimes head in unexpected directions and that draw on contributions from many sources, distilled into small, sharable notes. The photographs reveal the range of locales people share with one another via this game. Because the location of a geocache is given by its latitude and longitude, hunting for them involves the curious experience of simultaneously knowing exactly where you are going, but having no idea where it "really" is or what it will look like, until you finally arrive at the site. While that experience was common for explorers in earlier eras, it has become a rarer experience in our media-saturated world. I think geographical discovery and exploration are part of the game's growing appeal.

When I began geocaching, I assumed that having exact coordinates meant that a precise location would always be an important part of what I was being encouraged to find. So the photographs I made early on are at the precise cache locations. Gradually, I realized that sometimes the exact loca-

tion matters most, but sometimes people put the caches somewhere in order to prompt visitors to have a particular hike, to follow certain trails past a river or through a glade, to the top of a mountain, or to a city spot. Very often the cache is really the whole place; geocache owners are inviting others to see not just a tiny spot, but the entire area traversed to get to that spot. Once I appreciated this, I tried to make photographs that were true to that aspect of the geocaching enterprise as well. Therefore, while the latitude and longitude I give for each photograph and story are those for the cache itself (those listed on the Website), some of the pictures are at those locations, while others are points along the way. They depict the places that people today treasure enough to share freely.

Before you proceed to the text and pictures, please note that key terms associated with geocaching appear in the *Glossary of Terms* on pages 178–181. These can serve as informative reference points when you read the stories that follow in Parts I through IV and the Conclusion.

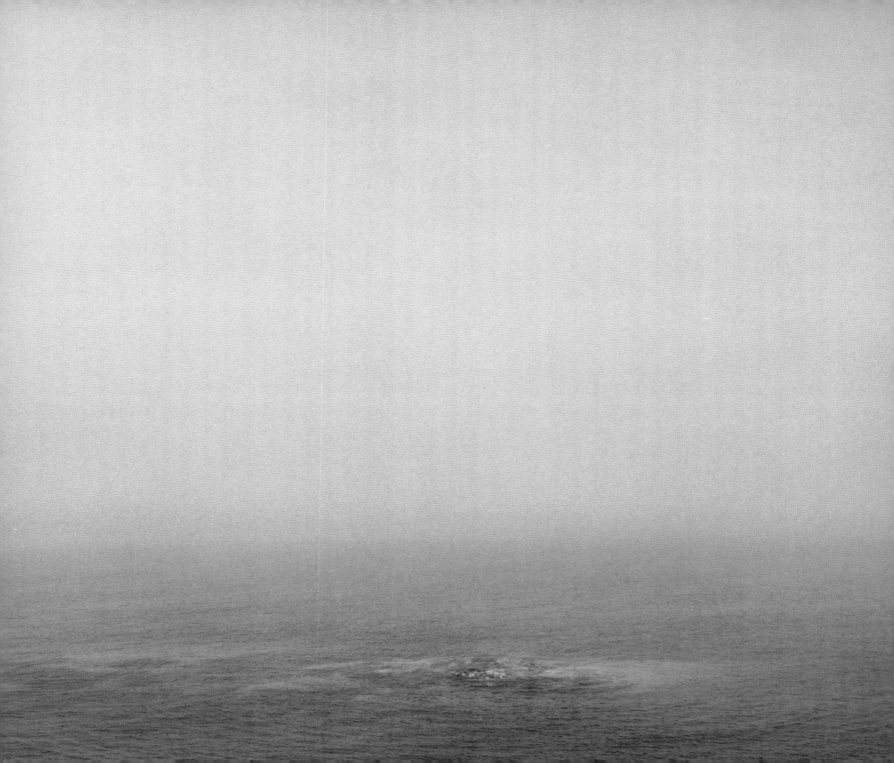

Like geocaching itself, this book can be approached on many levels. It is a travelogue, a diary, a book of pictures, a cultural investigation, an instruction book, and a meditation on the persistence of community, love of place, generosity, and personal encounter in the Digital Age. It is an ideal vehicle for one whose gifts are visual and literary in equal measure.

Ms. Kelley's experiences as a passionate geocacher are the foundation of her inquiry, which ranges widely across many cultural, physical, technological, and virtual landscapes. One trusts her observations because they are direct; their beauty seems to arise uncoerced from the plain facts before her and her camera. One trusts her speculations because they are so deeply rooted in her observations.

For anyone who has worried (and who has not?) about the survival of recognizably human connections in the wide wired and wireless world of the twenty-first century, Margot Kelley gives us reasons for hope, if indeed geocaching is the paradigmatic activity she believes it is. But she has not abandoned her critical intelligence to the high technical marvel of the GPS finder. Her enchantment with this phenomenon, which has elements of sport, game, hobby, social gathering, family activity, and geographical exploration, has not blinded her to some of the far-from-benign uses to which the technology essential to the pursuit can be turned, nor has it blunted her apprehension at the many disturbing features of the contemporary landscape turned up in her quest for the next cache. Between caution and enthusiasm, however, the struggle is not long; *Local Treasures* is far more likely to send you first to the geocaching Website, then to the local outdoor store for your GPS device, and then on to your first geocaching adventure, than it is to leave you wondering who might be watching you and from where.

Margot Kelley's *Local Treasures* is a treasure that should be discovered and relished by a broad range of readers and viewers. Anyone who loves good photography and good writing will be delighted to come upon a volume that knits both together in a seamless whole.

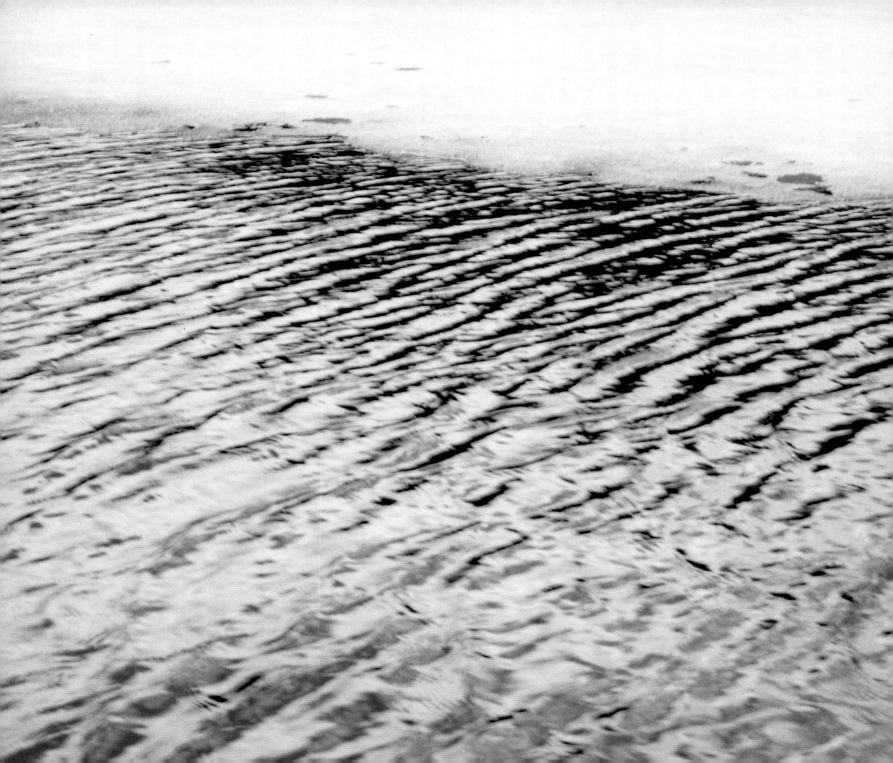

PART I: HOME TERRITORY

My husband Rob gave me a small wooden pin, years ago, that said, "she works in the margin/margin/she works in the margin." Louise Erdrich has one by the same maker that says, "she just wants to play Bingo." Her husband gave it to her when she finished writing *Bingo Palace*. The only time we met, Ms. Erdrich and I were both wearing our strange pins. Charmed by the coincidence, I was eager to make something auspicious of it; but it was not until years later, when I was on my first geocaching foray, that portent condensed into something like sense.

The first cache Rob and I looked for was at **Lone Mountain, Nevada**, on the border between Las Vegas and the Mojave Desert. It's about to become a subdivision; but until construction is complete, this land is absolutely liminal—no longer wilderness, but not yet absorbed into one of the fastest growing metropolitan areas in the United States.

Finding the cache wasn't easy. We fumbled to interpret the GPS readings. We disagreed about the circle of confusion. We needed the extra clues provided on the Website. Even with the clues, it took us an hour to scour thirty feet. Finally, Rob found it—a length of PVC tubing filled with toys. We left a disposable camera, took a refrigerator magnet, added our names to a long list of visitors. But the whole while I felt uneasy, imagined the people playing on the patch of green below were watching us, suspicious. We left just as the cops arrived, and our frustrations fueled a vague guilt that perhaps we'd been trespassing that whole time.

In the margins of the Bingo Palaces, it began.
In such margins, all begins.

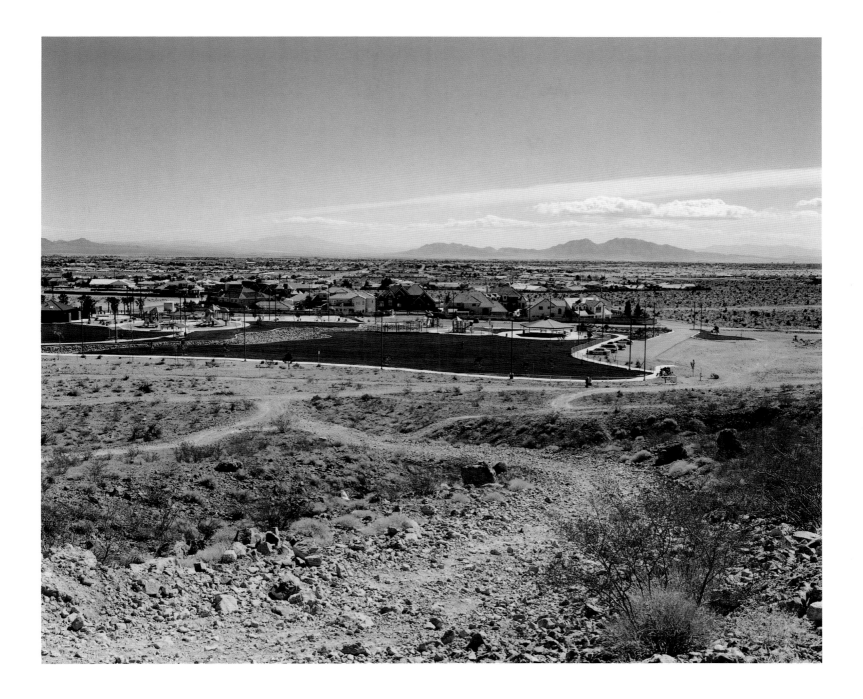

Dane Park is halfway between urban blight and urban delight, a small park in **Chestnut Hill, Massachusetts**, on the edge of a golf course. With only one entrance, no parking, and a few widely cut paths, it'd be the perfect place for high school parties if only a large Metropolitan District Commission facility weren't next door. But it's strangely foreboding, and walking alone, with dusk settling in, I lapse into imagining an especially grim episode of *Law & Order*, hopeful that a GPS, a cell phone, and a camera are enough to keep me safe.

When I find the cache tucked into the hollowed-out base of a tree, I wonder about "Jamie Wilson," the screenname of the person who planted this stash of treats. I think "Jamie" is a boy—twelve or so, that he lives nearby and that his father also plants geocaches. I think he begged his dad to let him try one, placed this one, and then got bored with caching. But in the end, I do not know. And even if my imaginings were all accurate, I don't know what such things would mean about who Jamie really is.

I also wonder why he chose this spot. What made it important to him? Of course, I've got a story about that, too, though again I cannot know. But one thing I do know, with more than intuition or imagination, is that someone who calls himself Jamie Wilson exists, and for that someone, a place— this place—matters enough that he encourages strangers to find the badly marked entrance, wander past the end of the dark park's trails, stumble down a hill, avoiding broken glass and rusting cans, all so that we might find a light brown cookie tin with teddy bears on it, overflowing with toys.

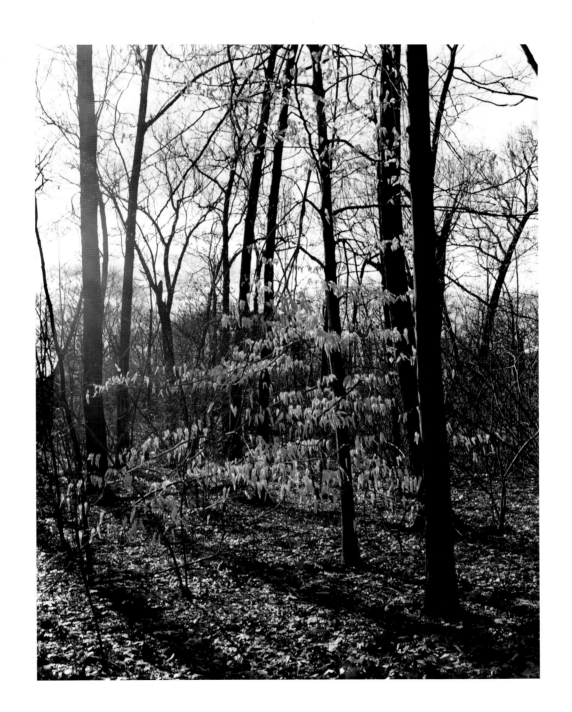

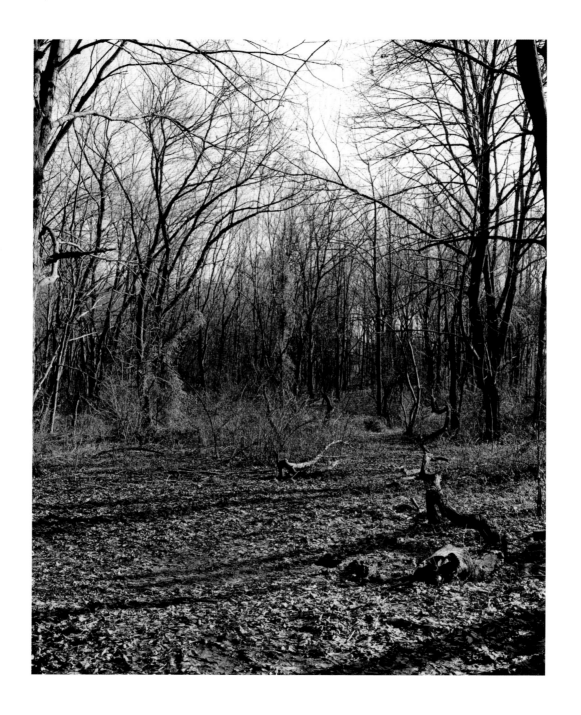

Returning to a geocache is immensely different from going there initially. First of all, you know where you're going—know where to park, what the terrain will be like, whether the hike is a mile or five. That changes everything. Second, you know exactly where the cache is—eliminating the treasure hunt element. I find these differences freeing: knowing it will be impossible to recreate the previous experience lets me have a new one.

Plus, I've been returning to caches in winter that I'd first visited in spring or summer, so I know the woods are going to look very different. In Pennsylvania, Massachusetts, and Maine, I've witnessed greens give way to russets and auburns, to a spectrum of dun I had long neglected to note. Here, in **Hatfield, Pennsylvania**, I came upon a patch of standing water, its edges slicked crystals, a thin skin suturing its way across, and pressed my hand flat. When I was here with my friends Margie and Carol in May, the stream was running high, transforming the hollows beyond its banks into algae-thick puddles. But today, squatting low on crusted leaves and mud, comfortably above the waterline, I use my body's warmth to melt the ice a smidge, to make a shallow impression of my hand, fingers spread wide, enticing a fresh sheen of water from ice in this familiar place I've never seen before, will never see again.

Around 1840, Babson Farm Quarry was established in **Rockport, Massachusetts**, on the edge of the Atlantic Ocean. For nearly 100 years, hunks of 450-million-year-old granite were blasted free, shaped by cutters, and carried away for use in monuments and as paving stones, for building bridges and banks. Until the economic collapse in 1929, granite supported local industry. Now, the abandoned quarry is part of a state park, one that tourists pay to enjoy.

I came here with a dozen folks. We separated almost immediately—content to enjoy Halibut Point in our own ways. Frank, Carla, and I reconnected just before I found the cache coordinates, and Carla and I searched hard to find it, using all the clues the cache owners had provided. Once we spied it, lodged beneath rocks in a natural amphitheater facing the sea, we passed around the clutch of snapshots left by previous visitors while Carla read aloud from the logbook entries.

Looking east, we could make out the hazy shape of the Isles of Shoals, off the coast of New Hampshire. They're among the last bits of land between North America and Europe at this latitude. The islands are also home to a Bluebeard legend. One of his many wives is said to have died out there—not by his hand, but of loneliness. When he left her for long pirating adventures, she is reputed to have stood by the shore intoning, "You will come back, you will come back, you will come back."

Now, the summer workers at the hotel on Star, the largest of the islands, repeat her chant as the ferry leaves each day. Listening to the din of voices, it's not entirely clear whether they are ordering or beseeching. But it's certain they yearn for company

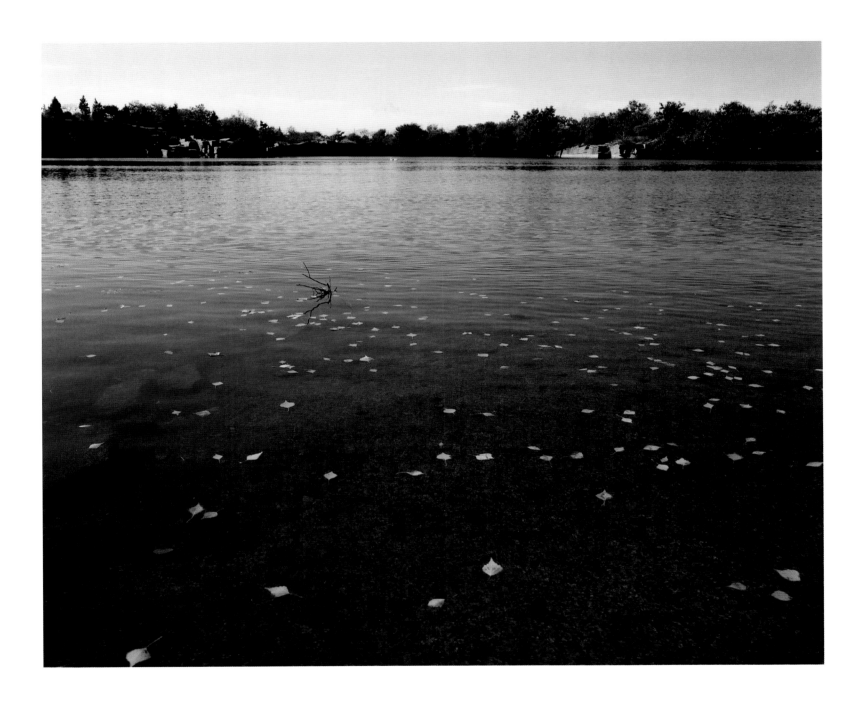

I first visited Beauchamp Point in **Rockport, Maine**, many years ago. I'd just enrolled in a photography workshop and my teacher recommended it as a place I might enjoy. When I learned he walked there each morning, I felt moved that he'd share a favorite place with someone he'd just met. In a world brimming with built-up venues rather than quiet landscapes, a willingness to part with information about less-traveled trails seems particularly generous, like a thoughtful gift.

I think about gifts a lot, about what it means to give and to receive—to do both with grace and an open heart. Many people, from a host of social, political, and spiritual traditions, think there's no such thing as a true gift, that people give them in order to get power or control or an ego boost. But Marcel Mauss, who has studied gift-giving in many ancient and modern cultures, says that, while there may be no such thing as a gift without implications, there is such a thing as "free, yet obligatory, giving." In fact, he believes such giving is a characteristic of an emancipated world. I like that idea a lot, though I confess when I first heard the phrase "free, yet obligatory" I was mystified. How can you be giving freely if you feel obliged?

Then I began geocaching. Each time I leave something in a cache, I try to make it an object likely to please whomever finds it, knowing that I haven't met the recipient, that I don't know this stranger's tastes, that he or she won't know this gift is from me. Each time I take something from a box, I know that someone else thought it would make a good gift, and that, in taking it, I am allowing that person's generosity to come to fruition. Yet, I don't feel any need to find out the person's name and write a thank-you note. Continuing the cycle of exchange—of small trinkets, sure, but really of energy, creativity, and a love of place—is the way I make manifest my thanks, the way we all do. And Mauss's cryptic words resound clearly.

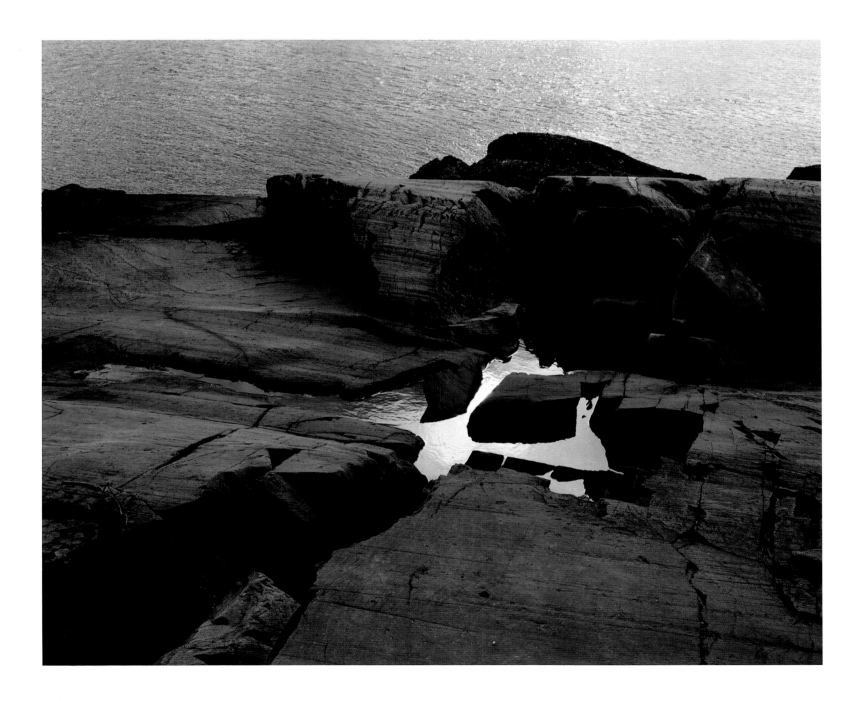

My mom and her sister walk 1.7 miles together most afternoons. When I visited my parents one day last April, I persuaded my mom to walk with me instead, while we looked for a nearby geocache. We drove most of the way, parking about a half-mile from the coordinates. The entry area, like many trailheads, looked like nothing more than a bit of extra gravel at the side of a state highway.

We followed the Nashua River, just outside **Lancaster, Massachusetts**. It seemed surprisingly unmarred by the lengthy drought. My mom was disheartened when we neared high-tension lines, but there was no way to avoid going under them. Over the last few years, there's been a lot of research on possible links between cancer clusters and such power lines. Though many scientists assure us that there is no link, I still wonder. After all, electrical fields affect even the most basic prenatal development. If they affect rapidly growing cells before birth, it stands to reason they'd affect rapidly growing cells after birth.

The steep hill we had to climb at the end was wet, leaf-covered, unpleasant in tennis shoes. But once we reached the top, we were greeted by a flat expanse of tiny pine trees and a cache so obviously placed it took just a minute to find. The folks who'd hidden it had put almost all of the emphasis on the journey, almost none into concealing the goal. My mother was delighted when we spied it, though I think she'd expected something grander, not a Tupperware with Pez dispensers and keychains and a logbook. I took a gear repair kit, assured her it would be handy. I left some treasures and a note. Then we retraced our route.

My parents have lived five miles from that park for eleven years and have never been there. I can't remember the last time before that day when just my mother and I went for a walk. Now we go often when I visit.

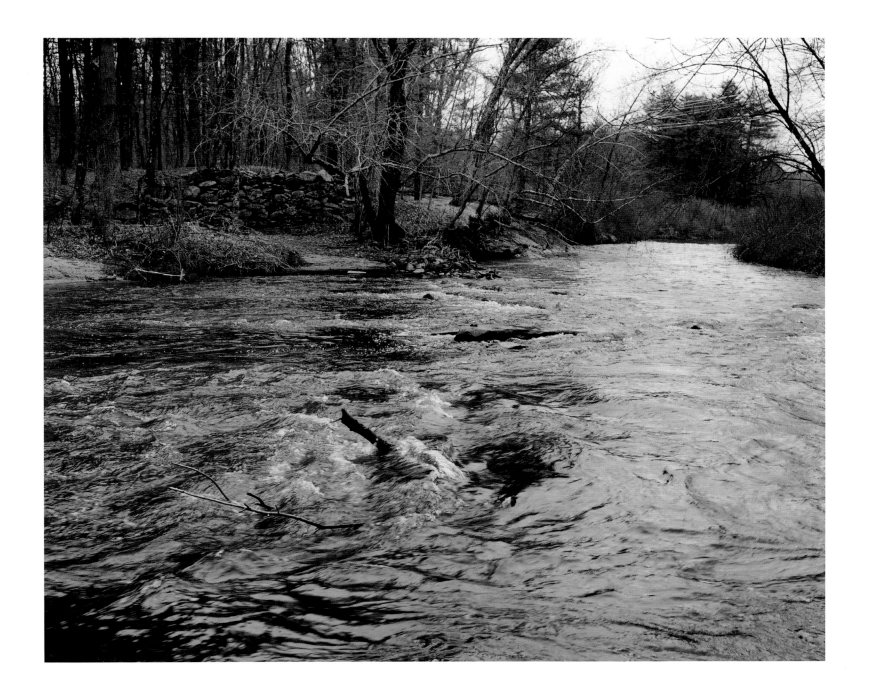

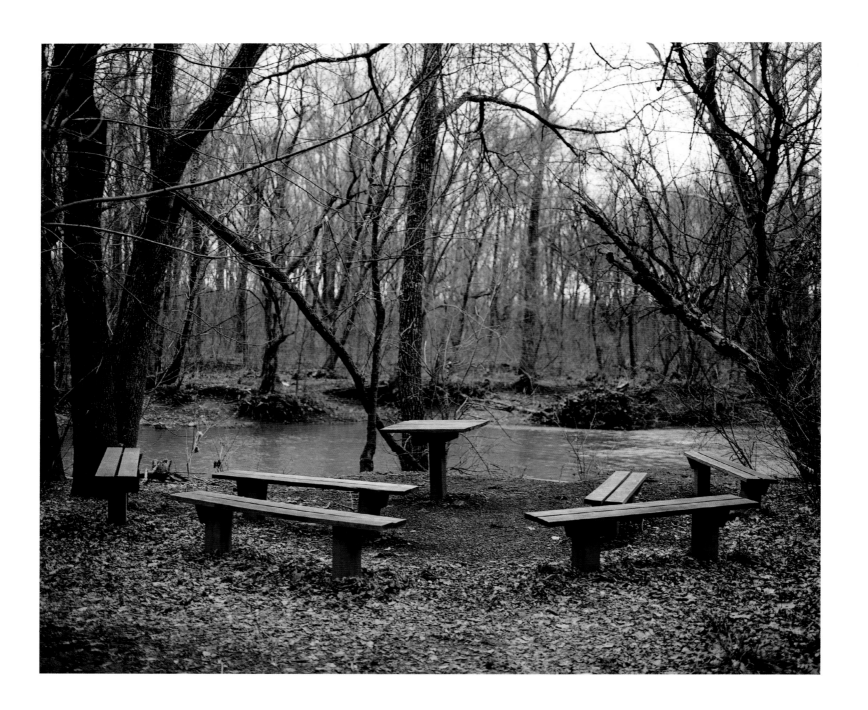

A few years ago, early in the era of Pokemon and Digimon, my friends Matt and Dave were among those whispering about the "International Pokemon Conspiracy" (IPC to those in-the-know)—a dark plot, cleverly masked by bright colors. Too gleefully, they'd point out that the IPC played on the American lust for virtually every kind of 'more.' *Gotta catch 'em all* rang through K-Marts and Toys 'R' Us, through kindergartens and McDonalds, through college dorm rooms and the whole of eBay. Adults and children alike began to spend astonishing amounts of time and money on these small toys; and Matt and Dave just shook their heads, smirking, pointing to America's new multinational consumerist nadir.

I don't collect, which may be why I found their assessments both funny and frightening. Maybe I'm missing some gene for discriminating among similar objects, or one for enjoying the heft of a complete set. Whatever the reason, that kind of quantity makes me anxious.

I mention all of this because the person who visited this geocache in **Evansburg, Pennsylvania**, immediately before me had already visited more than 1,000 caches. Not a large number, but impressive when one takes into account that I was here in December 2002, just 951 days after geocaching was invented. That cacher averaged more than a find a day.

His enthusiasm for geocaching made me wonder about how the infamous IPC really began. Did it start as a well-planned corporate conspiracy, or did a few overzealous collectors shift the parameters, transform lighthearted play into a hoarding craze? And I realize I want the guys to be correct in calling it a conspiracy. I prefer to think it was planned than to consider whether quadruple-digit geocachers will soon be chanting *Gotta find 'em all*, and persuading others to follow suit.

There are no binoculars on the viewing posts. **Camden, Maine**, its church spires barely visible among the trees at the base of this mountain, is home to a disproportionately high population of former CIA agents. I am tempted to bring two true things together to make another, to say that men who surveilled the world are using their waning power to prevent others from surveilling them. But such logic is faulty, even if the results turn out to be right.

So instead, I tell you this: To geocache for a year costs about $1,600. For that, one can buy a GPS, a low-end PC, Internet service, transportation to and from approximately twenty-five nearby cache sites, and assorted small objects to exchange in those twenty-five caches. It will seem to cost far less, though, to those who already have a computer, Internet service, and a car.

According to the CIA World Fact Book, the annual per capita income in 2004 was $1,600 or below in the following nations and places: Afghanistan, Benin, Bhutan, Burkina Faso, Burundi, Cape Verde, Central African Republic, Chad, Democratic Republic of the Congo, Republic of the Congo, Cote d'Ivoire, Djibouti, East Timor, Eritrea, Ethiopia, Gaza Strip, Guinea-Bissau, Haiti, Kenya, Kiribati, Liberia, Madagascar, Malawi, Mali, Marshall Islands, Mozambique, Nepal, Niger, Nigeria, North Korea, Rwanda, Sao Tome and Principe, Sierra Leone, Somalia, Tajikistan, Tanzania, Togo, Tokelau, Tuvala, Uganda, the West Bank, Yemen, and Zambia.

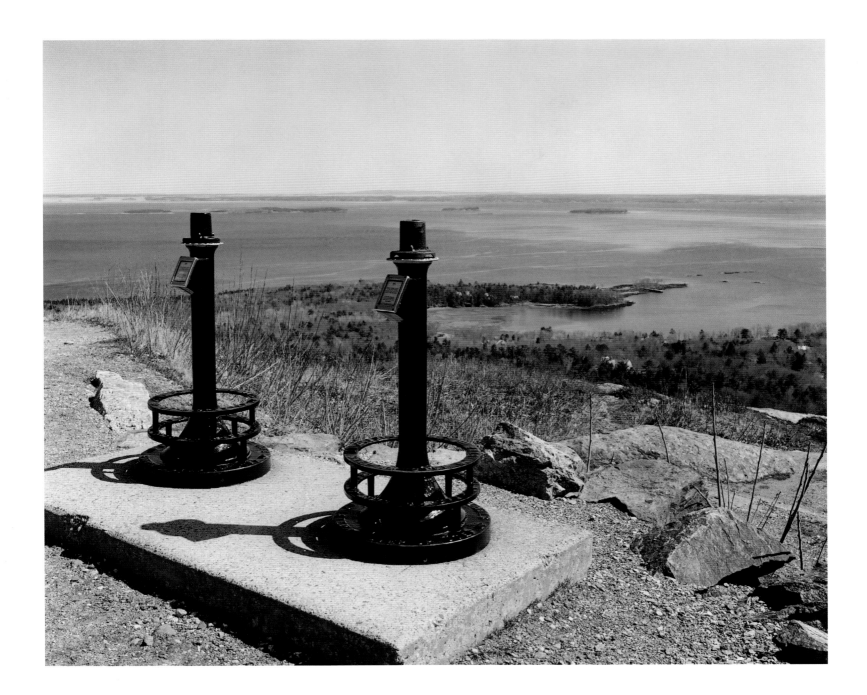

Driving past the orchards on my way to the Fyfeshire Conservation area in **Bolton, Massachusetts**, I had to weave cautiously between rows of cars parked deep into the road, slow to let folks cross from the orchards to the shacks where they weighed and paid for their fragrant pickings. I grew up nearby, and my taste in apples was formed in these orchards, where we'd come the first cool weekend of each September to pick Cortlands and Idas and Macs. I know lots of people who turn up their noses at McIntoshes, find them too sweet or too bland or too soft or too something. But I love them, largely because they remind me of my father teaching me how to peel them in a single long twirl, and how to cut them crosswise to discover the star hidden at the center of a smooth new world.

These orchards belong to the Johnny Appleseed Trail Association, named in honor of local boy John Chapman, the very real man who helped to domesticate Kazakhstan's export fruit and make it an American favorite by sowing its seeds wherever he traveled, planting thousands and thousands of acres of trees.

Passing beyond the range of apple perfume, I wonder about what people are really sowing when they plant thousands of geocaches all over the world, in odd little boxes like the one we found here, from which I plucked a book I knew my father would enjoy. I wonder what we hope to cultivate and what might be the harvest in years to come.

Mud season. Rural New Englanders know well that stretch after winter's dormancy when spring has not yet arrived. Some folks hate it because of the mess—viscous mud covers tires, the bottoms of cars, every pair of shoes or boots worn beyond the porch. That much mud can actually be dangerous; the weight triggers slides. Hikers are advised to avoid slippery mountain trails until a few warm weeks dry them.

I can't honestly say I like mud season, but I do enjoy watching nature rearranging itself, matter remade according to invisible algorithms. At the same time that winter dirt is thawing into spring mud, water is also transforming. The thick white, air-pocketed mass that coats the ponds and lakes starts to sublimate and melt. The top layers of ice become vapor, while the bottom layers return to a liquid state, each molecule's destiny determined by predictable laws and the happenstance of its location. This early April day, I braved the deep mud to reach **Sweet Pond State Park, Vermont**, where I found the pond poised between winter and spring, between solid and liquid.

Recently, my brother Lawrence explained liquefaction to me. It seems extraordinary. In fact, it's the kind of thing you learn about on the Discovery Channel (or read about occurring in a very poor country, far away), yet manage not to accept it, fully, as a real phenomenon. It begins with dirt—regular dirt, the sort that seems like a solid. If you have a large volume of dirt and pack it together, it will compress tightly, but it isn't fully compressed; it's in a matrix, a counterpoise of solid and water and air. Still, you can put a house on it, or a school, or a church, and your building will stay put. But sometimes, quite rarely, the water pressure surges momentarily. Then the matrix loses its integrity, and it's as though the dirt melts. Whatever is on top of it is instantly engulfed—sucked into the earth and covered over. Then the earth settles once again.

The world slipping and reforming, slipping and reforming: geology repeating itself.

Winter in **Rockport, Maine**, can be bleak, with more darkness than light, temperatures and winds that discourage all but the heartiest from playing outdoors. Still, I know many people who spend some time each Christmas Day or New Year's Day at the edge of the Atlantic, gazing east. One year, on Christmas morning, Rob and I went to a small conservancy, spent a while staring at the sea after we'd retrieved the cache. If we could see eleven miles over the flat water, we'd have spied Monhegan Island. And we squinted hard to try, knowing the only boats out at this time of year belong to Monhegan's lobstermen.

Lobstering's hard, dangerous work, and it can be fiercely competitive. Folks in-shore tend to set their traps in the warmer months, so neighbor ends up pitted against neighbor for the finite resource; no surprise that poaching is grounds for serious feuds. On Monhegan, though, the season is limited to half the year, starting (with luck) on December 1st, "Trap Day." The Monhegan captains work when no one else wants to, partly to get top dollar for their take, partly because it's a way to make sure there's enough winter work on this small island to keep the community vital.

Though the captains and their stern men are (obviously) a tough lot, they know they can't do it alone, that they must be able to rely on each other on waters that are deadly cold. And that's why, on Trap Day, competitiveness is set aside. On that first day of their new year, no one drops traps unless everyone does. If even one captain isn't ready, or is injured or ill, all of them wait to start the season 'til everybody can.

When Rob and I began spending time in **Maine**, and he was first encountering sea-thick fog, I regaled my Missouri-born husband with half-remembered bits of a childhood book. The little girl hero of the story could time-travel through fog, go back a century to visit people in the town that once abutted her own. The town had since faded away; just a few shallow house holes remained. I remembered loving it, and now wanted to read it again. But I could only recall scattered bits, was half-afraid I'd made it up. With a little sleuthing, Rob found it: *Fog Magic*, by Julia Sauer, which remains a much-beloved children's story.

Though I've not time-traveled via fog, I have place-traveled. Fog makes the familiar new, the ordinary breathtaking, the world beyond vision an improbable fiction. Details soften, colors shift, light follows different rules. At this park where Marshall Point Lighthouse marks the entrance to **Port Clyde Harbor**, fog has thoroughly recast space.

My sister and her family were visiting from Kansas, so we decided to geocache despite the fog. We couldn't see twenty feet ahead. Undaunted, Carli and Chip, my young niece and nephew, took charge of the GPS and led us all into a small stand of trees, where the fog was markedly less dense. I was surprised to find the remains of a stone wall and a route to the harbor. I'd been to this park dozens of times and never realized this area was part of it.

After we found the cache, we decided to go toward the harbor, walk on the water's edge, and take the long way 'round to the seaside parking area. As we scrambled over the rocks, more and more of the water came into focus. The fog was lifting, some spots almost clear, others still enshrouded. I don't know how—maybe refraction off the water, or light bouncing off the misty molecules—but the fog began to glow from within. And I suspect the fog (like a cache) makes places new not so much by obscuring what is, as by revealing what else is, what else has been there, unnoted, all along.

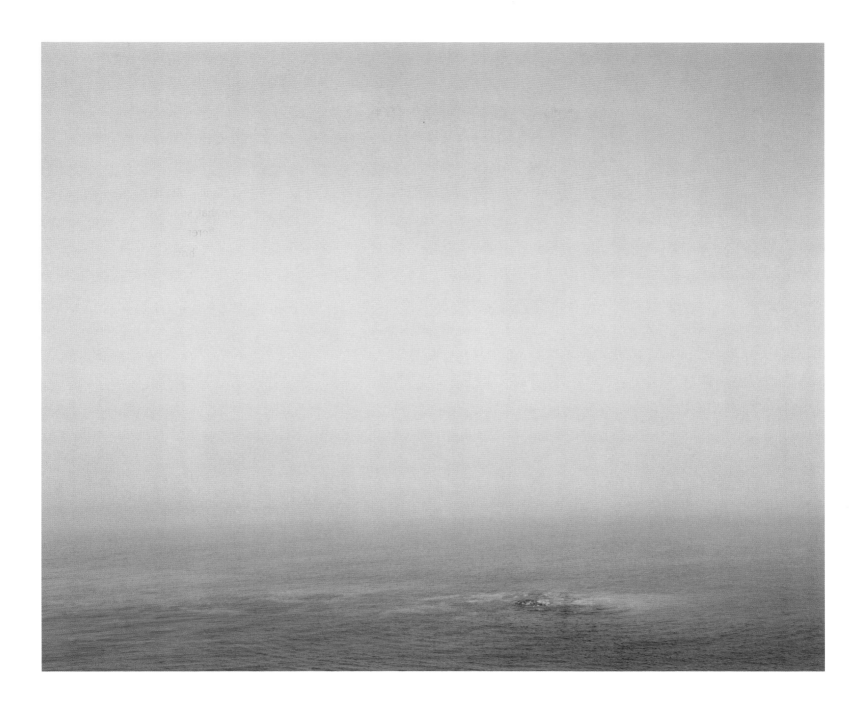

The GPS vacillated wildly, the signal hampered by the clotted rain and thick (though mostly bare) trees. Still, we kept looking; we were soaked, had been searching for two hours for a cache that was supposed to be easy to find. Now we just wanted to find it and go home, thinking the satisfaction of locating it would make us feel better. But we didn't find it. We found only the Connecticut River, outside **Greenfield, Massachusetts**, so swollen it had overrun its banks, covering old trails and carving new ones.

As the skies darkened further, we conceded defeat. Actually, only I conceded. As we trudged up the slope, Matt said that, of course, he wished we'd found the cache, but that, sometimes, one simply fails. I started to argue, to say that we hadn't failed, that we'd just had a different experience than the one we set out to have. But, even as I spoke, I could hear how ridiculous, how disingenuous, the words sounded.

I marveled at his calm, though I knew some of its source. It wasn't indifference to rain or to finding a cache; rather, it was that Matt has just completed a silent retreat at a Buddhist meditation center a few miles away. We were here because I'd come to drive him home.

He'd begun the retreat on the afternoon of March 19, 2003, just a few hours before George W. Bush announced that the United States would begin a preemptive war in Iraq, a war many were predicting would be quite short. When Matt left for the ten-day retreat, he'd asked, only half wryly, if I thought he might miss the war entirely. We'd walked these last few hours without either of us mentioning it. And I was glad; I assumed the transition from contemplative silence back to global conflict could only be painful, and I didn't want to be the bearer of bleak news.

When he finally asked, I had to tell him the truth: that the war was not yet over; that soldiers were still searching for weapons many doubted they'd ever find; and that the U.S. government apparently could not imagine conceding, could not imagine saying (had it grace for honesty) that, sometimes, one simply fails.

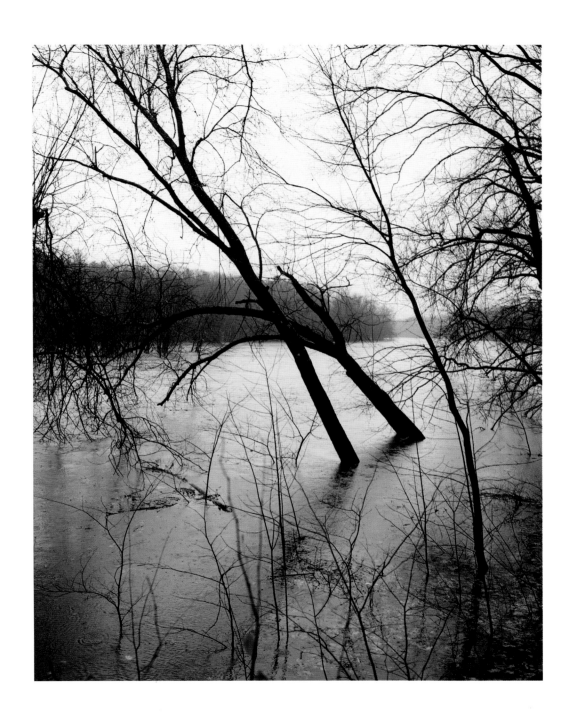

Seven of us convened at **Lake George, New York**, driving from Quebec, Massachusetts, Manhattan, Virginia, and South Carolina, meeting to renew and celebrate friendships born in Maine two years before. Two folks couldn't make it: one newly married, another too pregnant to travel. We'd chosen this upstate lake partly for convenience, but mostly for the beauty Alfred Stieglitz photographed here so many years before, and for the fun of walking in his footsteps.

We looked for his house, carrying picture books to compare vistas, trees, porches—trying to erase renovations from facades and to add decades to tree heights and girths. Only later did we find out the house had been razed, that it was not a common site for pilgrims after all.

This dock is in Bolton's Landing, where we did find some of Stieglitz's favorite views of the lake. It's also a recommended launch site for getting to a cache called "Almost Paradise"—and as close to the cache as I got, having neglected to bring a boat. Standing on the shore, knowing it was too far to swim, I heard Laurie Anderson singing in my head, reminding me that "paradise is exactly like where you are right now—only much, much better." In that moment, I felt sure she was right.

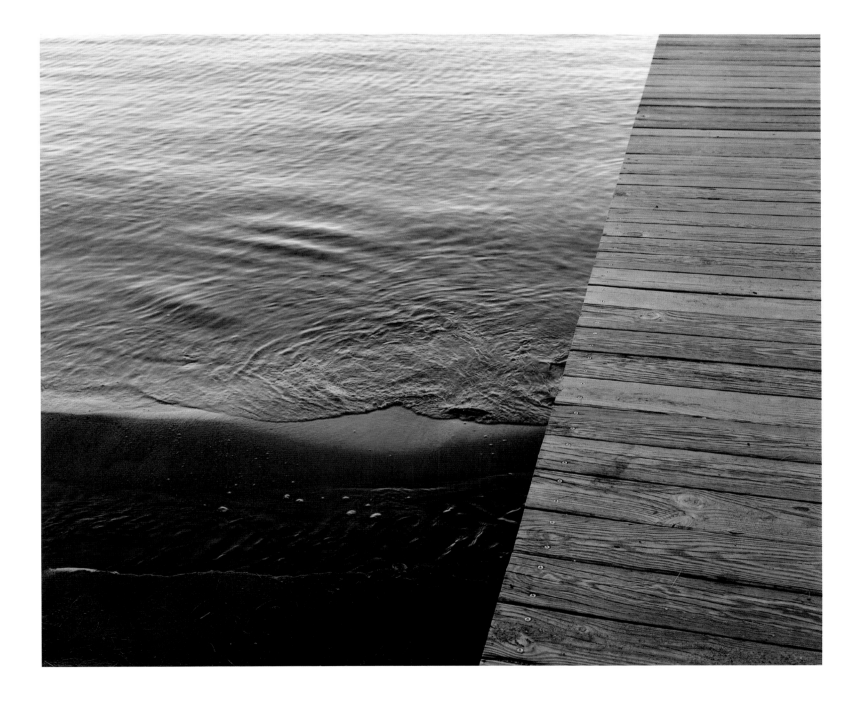

PART II: THE ROAD

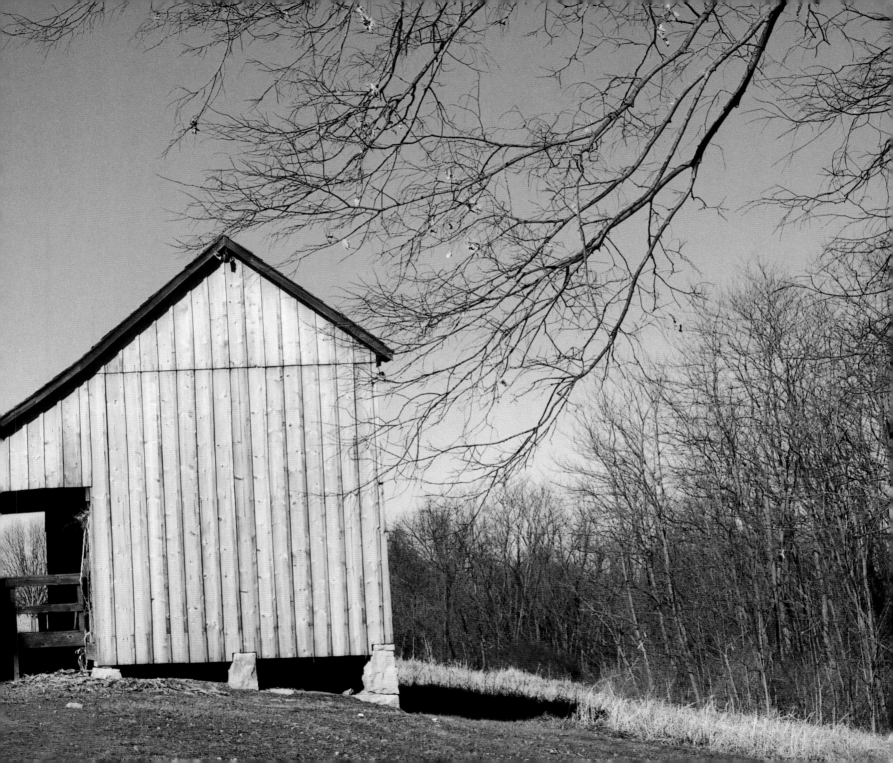

Rob and I came to San Diego for his friend Dan's wedding. They'd met in Missouri, at college. Then Rob slowly proceeded northeast, while Dan headed southwest. Now, they live about as far apart as two friends can if both are still in the continental U.S. Though they graduated nearly twenty years ago, a number of other college friends are also there—happy to reunite, especially for a wedding.

Dan adores the desert, so we spent our extra day out west geocaching there in his honor. We took I-8, a massive, beautifully engineered interstate, toward the **Jacumba Wilderness Area** in the In-Ko-Pah Mountains of **Southern California**. The cache is in a boulder field near the remains of old U.S. 80, the westernmost portion of the Old Spanish Trail that once linked St. Augustine, Florida, to San Diego, California. The cache owner had written that walking along this stretch of the first transcontinental highway would be like going back in time. "Pretend it's 1928. The road, the rocks, the concrete culverts and the scenery hasn't changed in 76 years."

For me, it wasn't so much being *back* in time as simply *time* that the road made evident, its hugeness and strange elasticity. Every quarter mile, the person who'd laid that portion had pressed his company's name and the completion date into the concrete. Keeping an eye out for these marks, I thought about how many quarter miles there are between the two coasts, how long it had taken to connect the Atlantic and Pacific, how long it would have taken early automobiles to make the trip. They had to stop often—not just for gas and water, but for repairs and many sets of new tires. Such efforts seem Herculean, but the alternative had no doubt been harder: in the 1800s, when young folks lit out for the territories, their families and friends knew they were likely saying goodbye for good. Comparatively, this road made it possible for people to travel and reunite with ease.

We walked only about five miles, but were so fascinated by the area that doing so took from very early morning until after noon. The next day, we took a nonstop flight from San Diego to Boston, ocean-to-ocean, in 5.5 hours.

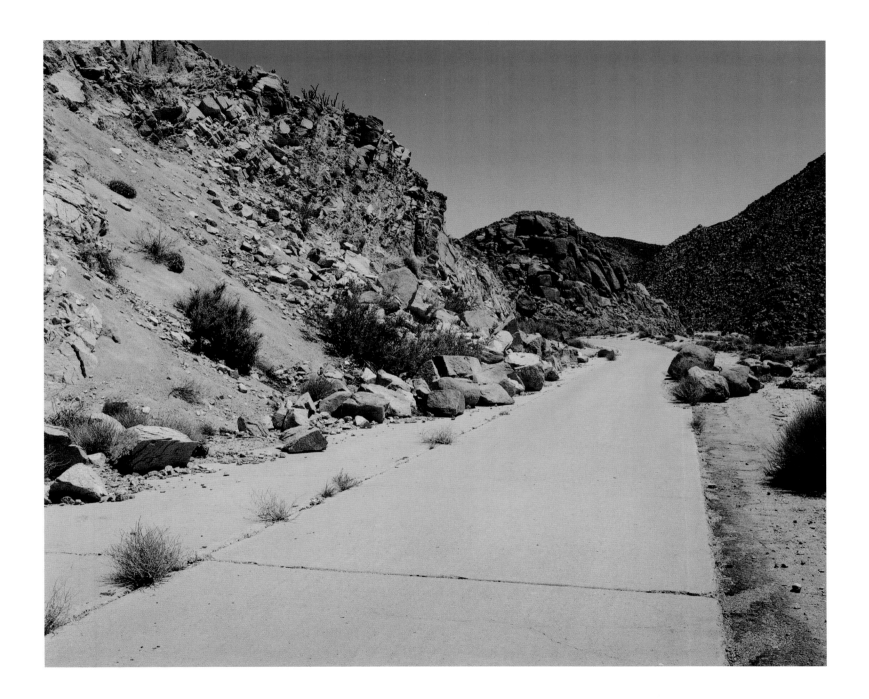

Back when my brothers, sister, and I were kids, we had a road trip ritual that must have made my parents weary. On long car rides, we'd each lean forward and reach an arm as far as we could toward the windshield (this from the back seat, mind you) every single time we drove across a state line. Whoever's fingertips were first into the next state would holler and gloat, feeling special for a few seconds. Thinking about it now, I marvel as much at my parents' patience as I do at the strange fascination these invisible lines held for us. What were we thinking? What did it mean to us to know we'd been one place, were suddenly in another—though so little had changed? I can't recall the reasons, just that we apparently cared inordinately.

My sister Gina and I drove to a virtual cache called "Tri-State." We had no idea what we would find as the answer to the cache question, but we knew—in a sense—exactly where the cache would be. A long road, 100th Street, cuts east to west, dividing **Iowa** to the south from **Minnesota** and **South Dakota** to the north. Just a few feet from a dusty farm road is a marker that indicates where Minnesota ends, where South Dakota begins, and where both leave Iowa behind. We each took a turn standing on the exact spot where the three states come together and split apart and tried to decide if an ant standing in the same place would be in all three states or in none (we decided *both*).

If you'd been with us, gazing west from that very spot, you'd have noticed that to the left is Iowa, to the right South Dakota—and that, while the fronts of your feet are in those two states, the back of the right one is firmly in Minnesota.

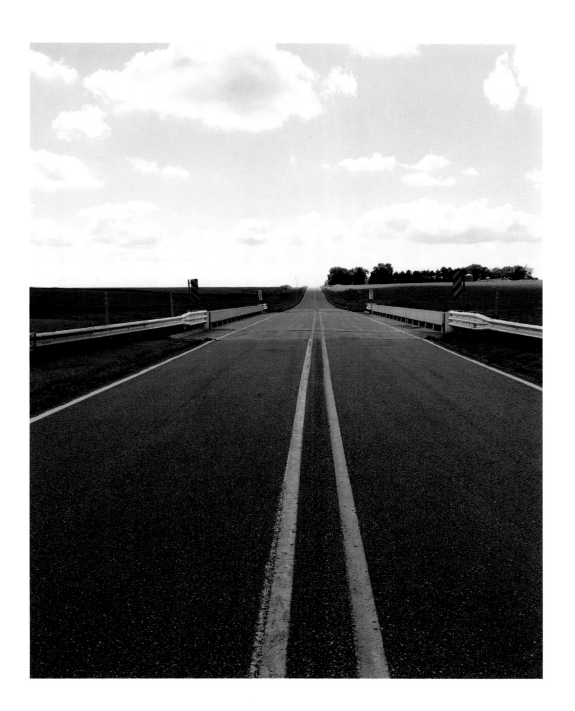

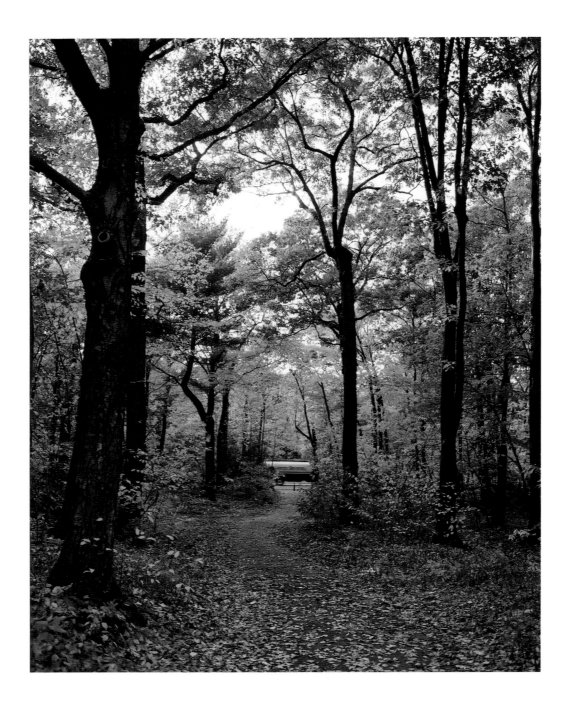

The first time I came to this park in **Chestnut Hill, Massachusetts**, I was able to find only one of the two caches hidden there. With an additional six months of geocaching experience under my belt, I returned to find the one that had eluded me. It wasn't just persistence that drew me back, though; it's that these unheralded parks have captivated my imagination.

In many ways, they've been the great, unexpected treasure. Of course, I love when a trek ends at a waterfall; who wouldn't? I love seeing long or deep, perched atop mountains or swallowed by dense woods; love pressing my face against a desert's wind-washed rocks, remembering there's as much earth in me as air and water.

But I hadn't foreseen all these parks—just twenty-five to thirty acres, or a whopping seventy-five to eighty if the local environmental group is both lucky and well-funded. Didn't know I would find them tucked behind a school, or between a church and a highway, or just after the airport, or in back of the cable company building, preserved, it seemed, wherever happenstance and hard work were able to claim a toehold against development.

I didn't dream of (much less dream I'd come to love) these scattered bits of unbedecked topography, seed-pearls of ordinary land.

The man we saw was there to hunt. He asked us about trails, had a shotgun, was wearing camouflage. It was obvious that he hadn't come to enjoy the exotic butterfly house, or to admire the historical buildings, or to take a leisurely stroll. He was in this sprawling park in **Chesterfield, Missouri**, to shoot something. Still, for a moment, I genuinely convinced myself that he was there to geocache.

It's silly. When I am on the train, I don't presume everyone else on the train is going where I'm going, doing what I'm doing. Ditto on the highway. I don't even do it when I am simply hiking. But when I'm looking for a cache, and the trails narrow, and the number of other people dwindles . . . well, then when I look around and see someone, I can't help but think that maybe we are searching for the same thing.

Earth, fire, water, wood, and metal. The five elements, ideally in balance. Here, though, at **Seneca Rocks, West Virginia**, I am struck by the imbalance, by the preponderance of fire. The mountain is startlingly beautiful, but the scars of a fire that took place two years ago are still clear. Heading up the main trail, we see scores of blackened trees, barren limbs, gutted stumps. They're scattered among healthy trees, as if only the frailest had fallen to the flames. And, in the first cache, we found a small container of marbles that the owner asked visitors not to take; it turns out this cache replaced one the owner made a few years ago (before the fire), and the marbles were all that survived. Now that I think about it, it's rare for me to encounter so much fire. I see lots of earth and wood and water when geocaching (and plenty of metal, if you count the car in which I travel to those caches); but living in the Northeast, I encounter few forest fires firsthand.

Symbolically, fire has little to do with scorching combustion. The fire cycle as it's described in the *I Ching*, for instance, is not about destruction or passion or any of the things flames often connote. It's about distribution—about energy extending outward from its source, about consumption of resources and exchange of goods and ideas. The fire cycle not only provides an apt way of describing what happens when fire meets wood, or when earth or water meets fire, but also a fitting way of thinking about how distribution works in general. In that sense, fire is always an unspoken, invisible part of geocaching, for the game is about a healthful distribution of life's pleasures. Players give of their time and energy as they wish, exchange things that offer simple pleasure, alert others to treasured places, all in the hope of fueling a cycle of warmth, of kindling—and rekindling—a dazzling cycle of fire.

Driving down Mill Mountain in **Roanoke, Virginia**, was like a bad rollercoaster ride. The descent—though eased by switchbacks—was often so vertiginous I'd lift off the seat, pulled by gravity (or perhaps by the intensity of my hold on the steering wheel). The cache I'd just visited was hidden near an immense star that adorns the crest, and I wanted to think of myself as hurtling away, like starlight itself, pressing forward into the unknown. But I was too scared to give myself over to road adventure or cosmic metaphor. The night before, I'd nearly died due to careless driving.

Leaving a parking lot, I'd swung left onto a wide, dark road. Cellphone in hand, I was regaling Rob with my day's adventures when I realized this wide, dark road was one-way, a grassy median separating cars moving in the direction I should have been going from the one I was going. Headlights of a car heading straight toward me clarified my terrible mistake. With no better option available, I swerved onto the sloping median, hoped I wouldn't flip.

Psychologists attribute the rise in cellphone-related car accidents to "inattention blindness," and explain that very few people can respond effectively to two sets of streaming data simultaneously. The solution, they say, is simple: Since we cannot pay full attention to two things at once, we should just do one thing at a time.

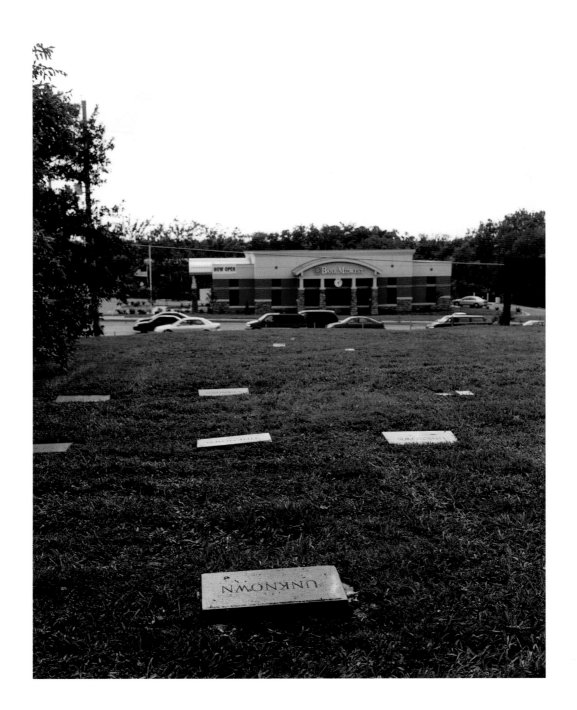

My sister and I took Carli and Chip to find "Beloved Elizabeth and the Unknowns" as their first geo-caching adventure, a mile from their home in **Overland Park, Kansas**. The tiny cache was in a cemetery the cache owner described as "a most unusual place. When you get there look around and you will understand why I named this cache the way I did." We quickly spotted not only the grave marker for Elizabeth, but also dozens of new looking gravestones all inscribed "unknown." The county historical society placed these a few years back to acknowledge those whose remains were unmarked. That act seems especially caring, even optimistic, to me—for urban sprawl is rapidly transforming this county, threatening to overwhelm such bits of the old landscape.

I was astonished by how many malls we passed on our way to the cache, even more astonished when I learned the area has a sustainable growth plan. For a moment, I wondered if we'd been driving in circles, if I'd been seeing the same few malls over and over again and just not recognizing them. But I wasn't. When I got home, I took a look at the USGS map (TKS0757) and found the tiny burial ground, Tomahawk Cemetery, on the list of "expected features" of the six-mile by eight-mile area the map covered, nestled among many places to shop, including the 75th and Metcalf Shopping Center, Cherokee Hills Shopping Center, Cherokee South Shopping Center, Four Colonies Shopping Center, Georgetown Marketplace, Glenwood Mall, Indian Creek Shopping Center, Kenilworth Shops, Lenexa Plaza, Lenexa Village Mall, Meadowbrook Village Shopping Center, Met 75 Shops, Metcalf 75 Shopping Center, Metcalf South Shopping Center, Nall Hills Shopping Center, Oak Park Shopping Center, Orchard Corners Shopping Center, Overland Station Shops, Ranch Mart South Shopping Center, Santa Fe Shopping Center, Somerset Plaza, Tomahawk Shopping Center, Trail West Shopping Center, Trailridge Shopping Center, Trailwood Shopping Center, Valley View Shopping Center, West Park Shopping Center, and the Wycliff West Shopping Center.

The cache is on Metropolitan District Commission (MDC) land, near **Malden, Massachusetts**, and the day I dead-reckoned my way to it the park was surprisingly mobbed. Apparently, the MDC holds an annual fishing competition, drawing hundreds and hundreds of young children who wear numbered vests and vie to catch what they can from the stocked pond. Some of the kids were implacably serious about their pursuit, others were just playing at the water's edge. I watched them for a while—but fishing to me is not an engrossing spectator sport, so I soon threaded my way up the hill, past an ambulance that was "on call" and an ice cream truck doing brisk business, and reached the cache itself.

The little trove was replete with incenses, herbal concoctions, sweet-smelling candles—fitting for something named a "New Age Cache." And I smiled to think of the drove I had unnoticeably joined, folks using GPS satellites and the World Wide Web, rather than bent paperclip fishhooks and pieces of hot dog, to participate in this new age's version of fishing a collaboratively stocked pond.

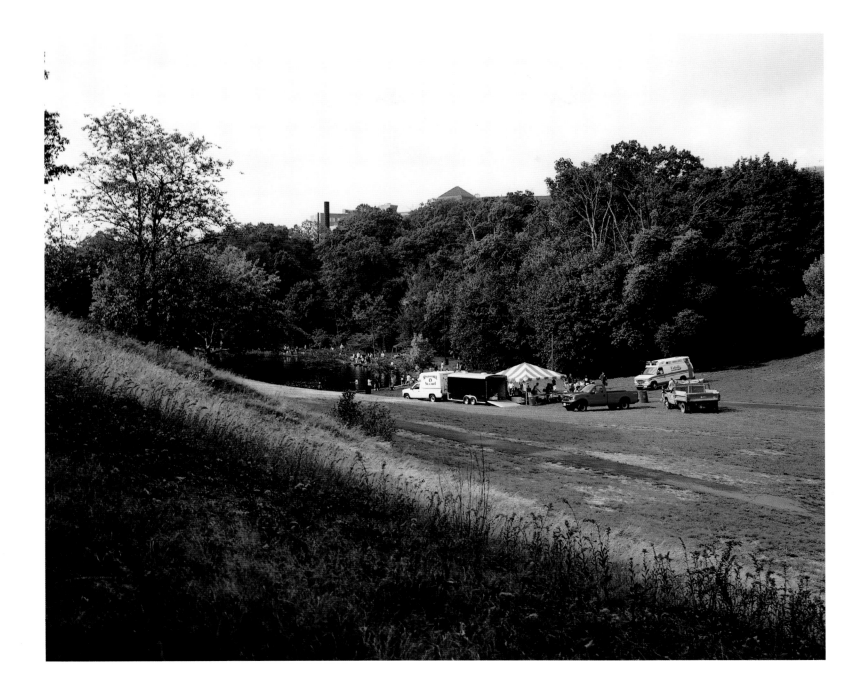

One spring day, Rob and I met our friends, Jeremy and Lisa, for brunch in **Belfast, Maine**. They were newlyweds, expecting their first child. They talked about onesies and Moses baskets with an entirely unfamiliar verve, so I was surprised that they laughed when I showed them the "travel bug" we were transporting, a purple teletubby wearing an official geocaching travel bug dog tag. They laughed even more when I explained how travel bugs work. Someone, in this case someone in California, placed it in a cache, asking whomever happened to find it to carry the traveler to the next cache visited. The owners and those who helped the traveler on its way could view its movements on the geocaching Website—could have an armchair adventure of sorts. I'd found the teletubby in Pennsylvania, carried it to Maine that weekend because that was the furthest from California I was likely to be for a while and I wanted to add as many miles to its roadtrip as I could. Jeremy just nodded, but I noticed Lisa was a bit misty—with hormones, most likely, but I'd rather think with empathy.

We had no trouble finding the nearest cache, which was called "Belfast by the Bay." It had been safely nestled a few feet from a railroad track bed that abuts the Passagassawakeag River, northwest of the actual bay. But the teletubby was too big, so we put him in the next cache we found, an oceanside cache at a place called Fort Point. Lisa called that night to see how our efforts had gone, and I told her about looking for the Belfast cache, how I'd assumed from its name that it would be by Penobscot Bay, rather than by the train tracks. I hadn't even realized the train still ran there. "Oh, yes," she assured me. "Just as a tourist attraction now. But it goes. I think we went by the station that time you visited me at school. It comes here. To Unity."

Four friends who'd been English majors at the college where I used to teach were visiting for the weekend, partly to celebrate three recently completed Master's degrees, mostly to renew bonds stretched thin by distance. Within minutes, I felt us slipping back into a way of talking that had lain dormant for years, the lexicon of these particular friendships. Like any people who've known each other a long time, we'd built a shorthand of quotes and references, ways to talk that were as much about other shared moments as they were about whatever was currently at hand. And, like all such languages, it seems obscure to all but those who live it.

Eager to introduce them to geocaching, we started out early on a Saturday to traverse the distinctly unsquare blocks around Kendall Square in **Cambridge, Massachusetts**, where I now live. We passed schools and stores, headed into what looked like an industrial wasteland. Then, suddenly, secreted among buildings that turned out to be part of MIT's research facilities, we found a tiny park dotted with cannons and flat-black sculptures of people in historical garb. We sensed that we'd arrived.

And we had. Locating our prize—a container no larger than my fist, densely stuffed with notes from previous visitors—we began to read what they had written. My friend Lori marveled that it was as if we'd tumbled into some secret alternate universe. Moments later, a passerby casually called out to us, asking if we were geocaching. That amazed Corey, Judd, and Dan—who were suddenly aware that they'd entered an invisible realm, an "unplace" interlaced with the world they thought they somewhat understood. Dan mentioned Thomas Pynchon's book, *The Crying of Lot 49*, which we'd read together in a course several years before. In it, the protagonist stumbles upon an alternative communication system. The more she wanders the city, and the more research she does, the more she comes to believe this network is huge and that it's been around for hundreds of years. Though its name varied over time, its symbol—a muted post horn—remained the same.

Unable to resist, we penciled a post horn into the logbook, and now silently await reply from the geocaching empire.

Often, geocache owners place their offerings in a place that invites—sometimes even requires—that visitors follow a specific route. In such cases, the path itself is clearly part of the destination. I believe that was not the case here, in one of Frederick Law Olmsted's parks, in **Boston, Massachusetts**, for the most logical path led through a person's home. Intent upon finding the cache, I only recognized clothes and a mattress as someone's belongings and not trash when I was literally upon them.

Hurrying to take myself out of this personal space, I tried instead to put myself in the inhabitant's metaphorical shoes, tried to guess what observing geocachers tromping within yards of his home might seem like. And, from that vantage, I could imagine that people leaving small presents for strangers in boxes hidden in public parks could seem absolutely absurd, or like choosing a strange and difficult route to achieve an easy aim, or like the most sensible game in the world.

All weather is local. So local that, in New England, tiny portions of Connecticut and Massachusetts were D0 (the official designation for "abnormally dry") much of this past spring, as was most of Maine—even though adjacent counties were fine. Across the nation, the contrasts were even more pronounced: here in **Davenport, Iowa**, the rain-swollen Mississippi River overran its banks, making it impossible for us to reach the cache on Credit Island. But, out West, several years of drought have reduced Lake Powell to less than half its capacity, dangerously shrunken the Colorado, and made the dribbling Rio Grande seem cruelly named.

Even as they intone the mantra of locality, meteorologists who study regional and local changes correlate new weather data with information about ice ages and interglacials, with geologic clues to the making and unmaking of land and ice masses, with everything they can glean about air and water currents and the assorted influences we humans bring to bear. And while recent computing technologies no doubt make such work more manageable, I'll bet the whole job of making predictions seemed a lot less thorny before 1972. It's more fun to do tasks that are merely difficult than it is to essay the impossible. And when—at a meeting in '72—meteorologist Edward Lorenz unveiled the "Butterfly Effect," the popular name for the principle that tiny changes in weather (or any other complex system) can lead to extraordinarily large differences in outcomes, he implicitly said we could never see far enough back in the system to take into account all the data. And, similarly, we can never reliably predict very far ahead.

We see Credit, but
have no boat. Silly! We thought
roads would be on land.

All weather local;
and all weather global. An
all-season koan.

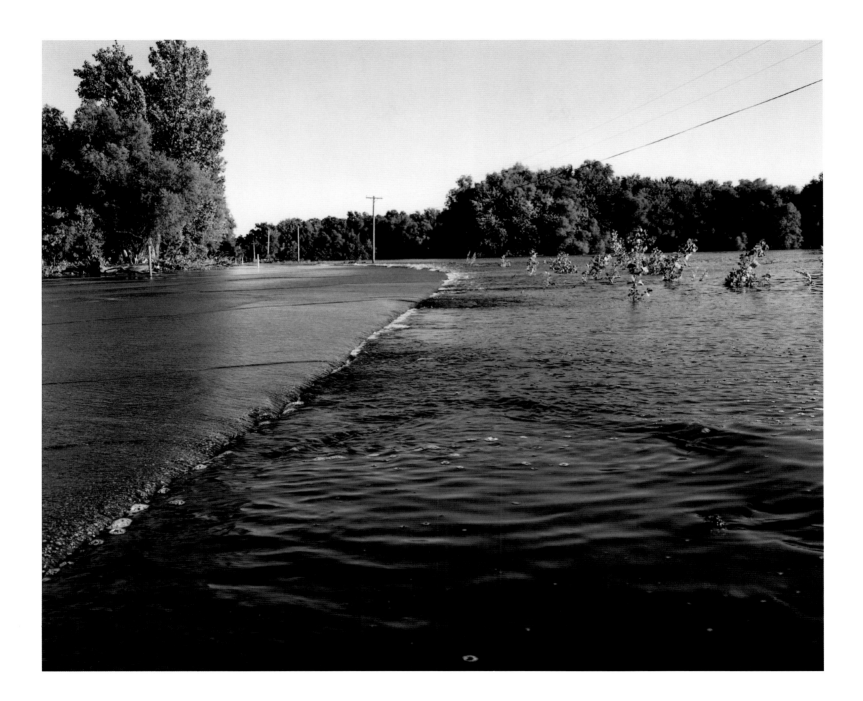

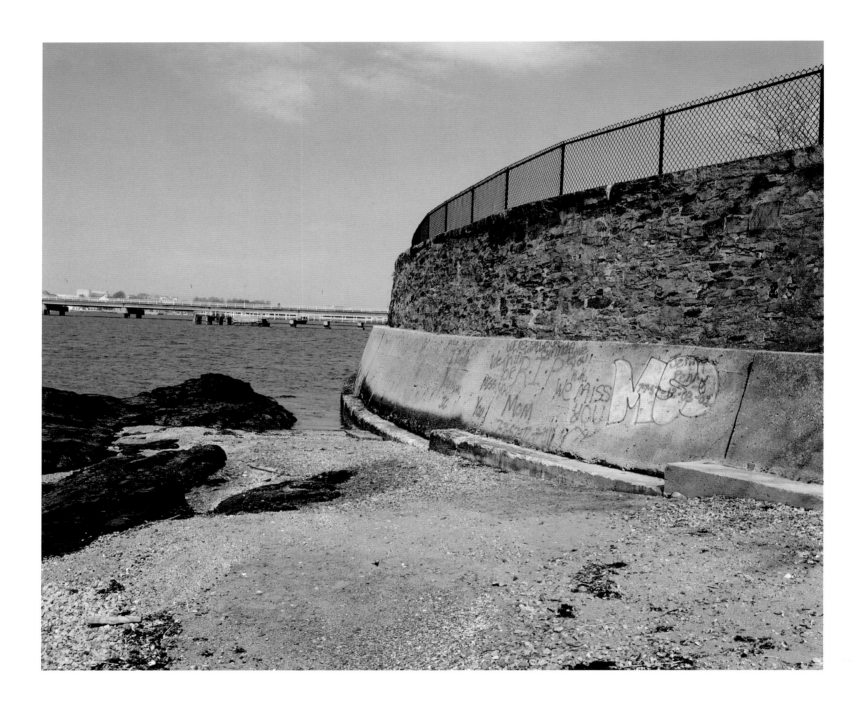

I'd come to **Newport, Rhode Island**, for a photography conference, but was skipping a session so I could geocache by daylight. This small town, known as "America's First Resort," grew famous as the summer-home-away-from-home for wealthy Victorians who built sumptuous mansions overlooking the Atlantic Ocean. The main streets are lined with charming homes from earlier eras, interspersed with shops and restaurants to entice the tourists who still flock to this vacation spot. Conferences such as the one I attended add another breed of visitors: people who meet, often just once a year, to talk about their professions and to network while also playing and sightseeing.

Placing a cache in a town famous for being lovely strikes me as a paradoxically tough task. Before arriving I wondered if local geocachers would try to highlight parts of Newport that visitors tend not to see, wondered what such places might be. This cache was in a 110-year-old neighborhood park, the container itself tucked in a crack in a graffiti-rich retaining wall. Battery Park is much like small parks all over the United States—unusual only in abutting a bay. Half a dozen inscribed benches face the water; and I walked from bench to bench, reading the names of people who probably enjoyed this park, and who probably no longer could. Sitting on one, looking across the bay, I saw the lighthouse and bridge the cache owners mentioned as pleasing parts of the view.

Before this bridge connected Newport to neighboring Jamestown, the ferries that carried most of the island's visitors relied on lighthouses to illuminate the coast. Here, it's easy to remember I'm on an island, to remember why islands seem special. I feel the solidness of this bit of earth, understand why so many houses have stayed in the same families. But I also see the imprint of centuries of traverse, a living history of the technologies used to connect peoples and places. Indeed, though I look like I'm alone, gazing out at the bay, I'm not. I've just learned the names of beloved local residents, signed a geocaching logbook, and speed-dialed a friend I'll meet at the conference.

Places appreciated, lives intertwined, tools well-used: more than haphazard facets of a cache in "America's First Resort," they are our most important legacies—our last, best hope.

The cache owners warned that it'd be hard—not so much to find the cache in **St. Augustine, Florida**, as to do so without being observed. In fact, they described this cache as specifically "for the enjoyment of the truly adventurous or just stupid," adding that folks should "come prepared with a good excuse." Across the street was a *Ripley's Believe It or Not!* museum, so most of the excuses that my friend, Janet, and I invented began "uhh, believe it or not…" In the end, we didn't need them. None of the hundreds of people who walked by asked why we were spending so long pushing aside bushes and peering at mulch on a median between a trolley stop and a busy street. No one offered to help us search for whatever we so obviously and ardently sought.

A few weeks earlier, Rob and I had been in the desert in California, walking along what's left of U.S. 80, the other end of the Old Spanish Trail. It truly is the antithesis to bustling St. Augustine, with its cement orb in the middle of downtown marking the start of the trail. Rob and I didn't need to worry about being observed out West. The only folks we saw during our hike there were two border patrolmen. And though they conspicuously noted our car (and likely our touristy demeanors), they didn't speak to us either.

Please don't misunderstand; I was glad not to be interrogated. Still, such disregard seems strangely fraught, at once appropriate and callous, respectful and troubling. When the Old Spanish Trail finally connected the Atlantic and Pacific coasts, nearly a century ago, American communities were far less dense than they are today. So people didn't need—and didn't need to give each other—such wide berth. And though the population was large enough by then to make for many potential strangers, Americans often spent their entire lives in a single town, insulated from the unfamiliar. Today, much of America's lands are thickly settled, the roads well-made and oft-trod, with people from far away visiting even remote deserts. With little space between us, we crave the legroom we so industriously eliminated. And simulate such space daily with a willful blindness we've convinced ourselves to see as kindness.

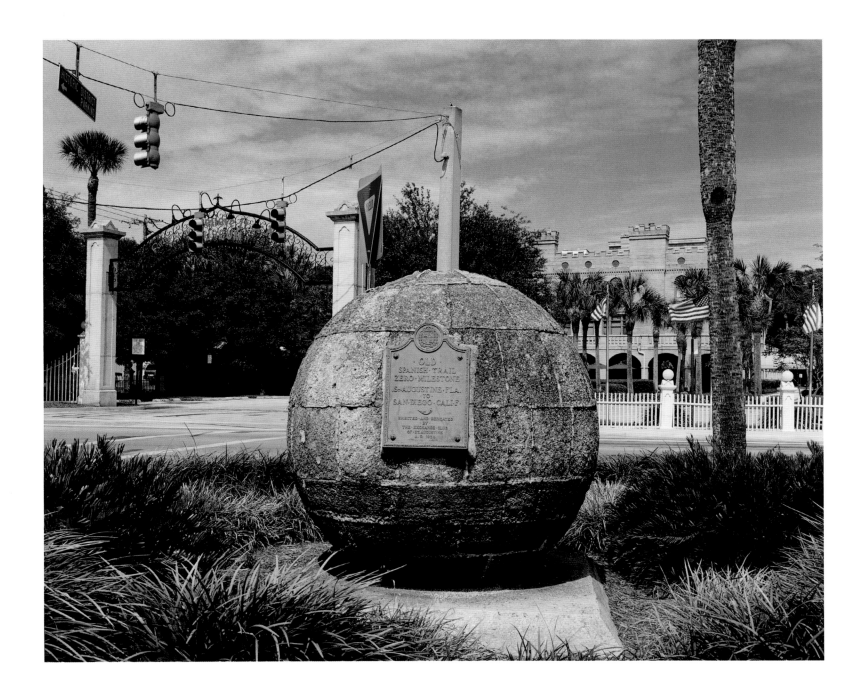

PART III: THE PATH

I really would not mind if a passerby asked me what I was doing as I strolled through a park, peering at a GPS. I'm sure some people must wonder; I've got to look odd, relying on a satellite guidance system to orienteer in nature conservancies full of color-coded trails.

But I do mind that here, in Cherokee Park in **Louisville, Kentucky**, the police stopped me. They insisted on checking my gear, demanded proof of identity. I felt as violated as I do at the airports nowadays when I am taken aside and searched. I tried to justify their invasion, noting my out-of-state license plate, my random walk through their territory, my intermittent checking of maps and making of pictures, not to mention several ungainly instances of clambering onto rocks and lying prone to peer under them. I told myself such activities look suspicious, especially when undertaken by adults, and that, after 9/11, it is reasonable for police to be proactive.

Making matters worse, just a week later, in a city 1,000 miles away from this cache, it happened again. And the next day, I got back a camera I'd left in a geocache in Phoenix Park, in Dublin, Ireland. All of the images at one end of the roll were traced with strange flame marks, vestiges of Customs' earnest x-raying. And then, when the U.S. invaded Iraq in 2003, the Pentagon announced it might dither GPS signals again, for the sake of national security, a move that would make geocaching (among many other activities) impossible.

Ruefully, I recognize that such suspicion-tinged moments are not ancillary details; they are as much a part of geocaching as are idyllic walks. And that this game, so eloquently *of* our moment, may well be imperiled *by* our moment.

In our salad days, my friends and I used to like layered drinks, concoctions the bartender had to prepare carefully so the various liquors didn't mix. We liked the succession of tastes, of course, but I think the real delight was due to not appreciating fully that different fluids have different densities. So these drinks seemed to defy the laws of nature, making them all the headier.

Geocaching reveals a thickly layered world, one in which a place *is* always at least two places. On this rails-to-trails route in downtown **Mankato, Minnesota**, some folks are at a bike path, a few police officers are on a shortcut to their firing range, and we are on the prescribed trail to a cache. That we are within feet of one another, but in entirely different places, is a point whose obviousness has not made it seem less profound to me.

More than this variety of ideas about what the trail is, what strikes me on this hike is how the place itself can change from moment to moment. Swirls of smells surround us, eddies by turns delightful or disgusting: the wet parking lot warming, the Minnesota River unfolding its fresh piscine scent, weeds tempting bees with their sweetness. And invisibly counterpointing these, the implacable rankness of waste being treated, startling wafts of dank protein (there must be a rendering plant we can't see) and bug spray, liberally applied. So much bug spray seemed awful until it offered relief from the odor of the abattoir. The waves of smells transform this place: when we like the smells, we say it is lovely; when the stench gets strong and unpleasant, we wonder aloud why someone picked such a repulsive place to hide a cache.

Those long-ago drinks, I think, were a primer in the physics and metaphysics of layers, hinting neatly—and sweetly—at what I'd learn later: that layers do not defy the laws of nature, but instead are everywhere the evidence of them, the intermingling, overlapping, often invisibly eddying strata of seeming, the thick complexity of what is.

My sister and I crossed the bridge that traverses **Devil's Gulch, South Dakota**, clinging to the railing as we look down, trying to guess how far we'd fall to the rocks and waters below. Jesse James is said to have leapt across, recklessly spurring his horse that he might escape the angry posse chasing him and his gang after yet another bank heist. No such unrest marred this morning; the gulch and surrounding park were tranquil. The waters were low, gently plashing rather than roiling over the falls; and we arrived so early in the day that the sun hadn't yet warmed the crickets. The only sound besides our own was the wind washing through the high grasses just above the gulch—but that's no small thing. Not a high rattle or a gentle swish, these grasses declared their endurance with a deep, undulating whirr.

The cache was under a tree at the edge of these grasses, and while Gina looked through it and added a note to the log, I climbed the hill to see how far the field continued. Strangely, the hill itself seemed to keep going; what looked like a slight rise kept lifting, and I felt no nearer the crest when I heard Gina calling, concern limning her voice. Tall grasses and trick horizons hid me from view. Afterward, in the car, I told her about a description of such grasses in Willa Cather's *My Ántonia*. The book's narrator, like me, is an East Coaster experiencing prairie grasses for the first time. And what he notices more than anything else is the "motion in the landscape; in the fresh, easy-blowing morning wind, and in the earth itself, as if the shaggy grass were a sort of loose hide, and underneath it herds of wild buffalo were galloping, galloping."

I carried a similar sensation home, bringing a bit of prairie back East in the feel of heavy grasses pressing against my body, in the rough touch of unfamiliar foliage, in the recognition that knowledge itself can be scored into one's skin.

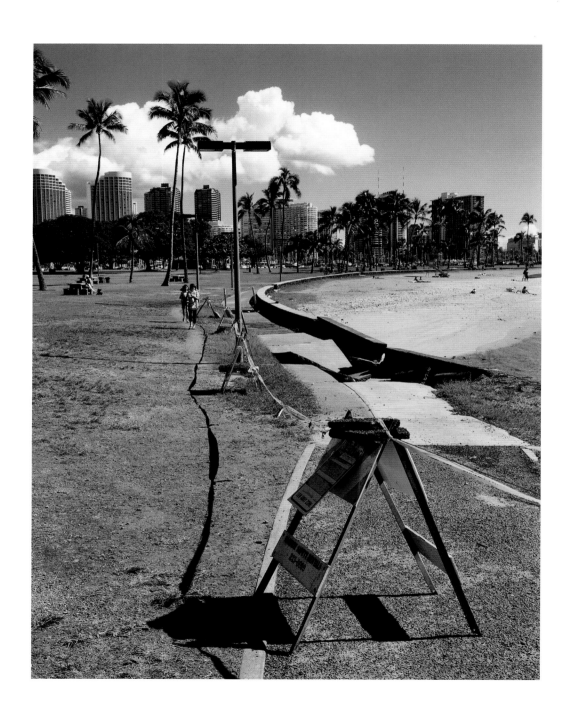

At the northwest end of **Waikiki Beach, Hawaii**, is Ala Moana Park, a small green jutting toward the sea. When I visited the cache at sunrise, I shared the space with outdoor sleepers, T'ai Chi practitioners, and unhurried walkers. Returning later in the day, I saw tourists, joggers, and cuddling couples. The morning folk were scattered throughout the park, widely dispersed across the available space. Some curled in and under the ample branches of the banyan trees, others reached from the earth toward the sky as they wound through slow stretches, and one old man shuffled across the sand, listening intently for the amplified squeal of detected metal. The afternoon folk stayed more to the asphalt walkways and adjacent benches, perhaps honoring a "keep off the grass" decree that early risers feel freer to ignore.

I think "keep off the grass" signs in parks are goofy, but apparently landscape architects and designers do not. In fact, they have developed a whole host of strategies for limiting where people walk. One, ironically, is not to lay down paths, forcing folks to walk across the sod. After a few months, the places that people have tramped form muddy routes. Only then are the paths added—exactly where most people seem to want them. These ruts, bodily declarations of our wishes, are called "desire lines."

At Ala Moana, the most desired path by far is the one that sutures water to grass, ocean to island. Our impulse to linger at the edge of the sea is apparently so strong that this path is too close to the water in places. On the south side, it's caving in, as wind and tide claim the sandy soil beneath. I'm sure these cracks will be repaired, and just as sure they'll form again. For even as air and water conspire to undermine this tracing of desire, we blithely reinscribe it. I think it might be better just to leave the cracks, apertures through which we can peer at nature less fully-dressed. Through this cleft, I can see the inexorable effects of flux and flow, the outcomes of forces encountering forms. And, in this clash between what we may want and what will be, I am able to glimpse fresh hints of the basic laws of nature, of the physics of desire.

N 21° 17.060 W 157° 50.898

Triboluminescence is a simple and beautiful phenomenon. It is a flash of light, the glow emitted when many minerals, especially feldspars, are struck or crushed. Outside the geological community, it is most frequently cited as the reason Wint-o-Green Lifesavers make those bluish sparks when you crunch them in the dark.

I came to this site, the chapel at **Bellarmine University** in **Louisville, Kentucky**, and listened to the bell sound the hour, as visitors are urged to do by the owner of this cache called "For Whom the Bell Tolls." In the stillness after the last peal, I quickly found the cache. Looking at the notes of those who'd visited before, I saw how many places we'd come from, how many miles we'd traversed to reach this site. I think I'd come the greatest number of miles, but I'm not positive. Many others had also traveled quite far.

We'd all come here seeking this portentously named cache, trusting in the kindness of strangers that it would be ominous in name only. As I thought about how far people go in search of that next cache, I realized that saying we came because we were seeing this cache risks putting too much focus on the cache. Really, it would be more accurate simply to say that we came because we were seeking. And I wondered if triboluminescence occurs in such moments as well—as metal strikes metal in sonorous bell peals, and seekers find what they've been looking for.

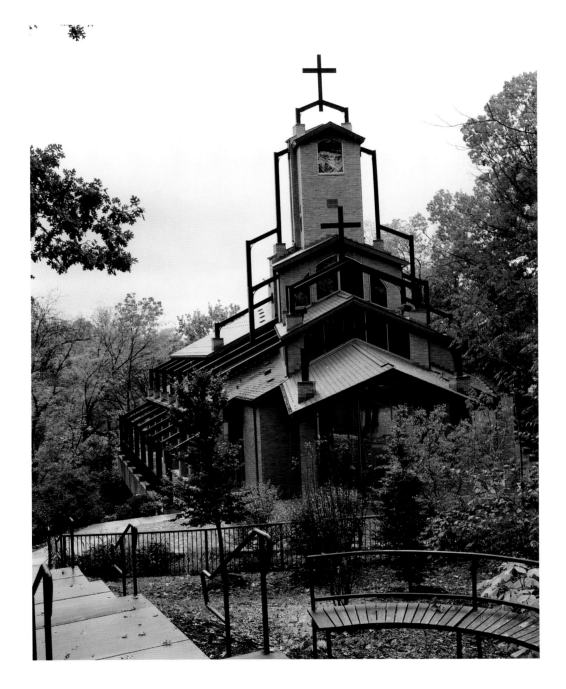

There's a story that F. Scott Fitzgerald and Ernest Hemingway were chatting when Fitzgerald said, "The very rich are different from you and me," to which (reputedly) Hemingway replied, "Yes, they have more money."

Urban caches are different than rural ones. They're usually small—often "micro caches," just a film canister with a slip of paper to sign, or "virtual caches," with no objects at all, just something for you to see and then acknowledge to the owner that you've discovered. In such cases, once you arrive, the answer is usually obvious. But the cache Katie left in Beacon Hill in **Boston, Massachusetts**, was a regular one, which is probably why it went missing—though, to everyone's credit, it lasted six weeks.

With urban caches, rarely is a beautiful hike or a clever hiding place being offered. Sure, some of the sites are idyllic spots known only to locals; often, though, I've left urban caches perplexed as to why anyone would invite me to come *here*. But while the particulars might be opaque, I understand someone wanting to add a piece to the invisible city, wanting to contribute a node to a network composed by thousands of anonymous makers to share with any cognoscenti who happen through.

Wanting to contribute to a world that's different. Different. Self-made. And oddly rich.

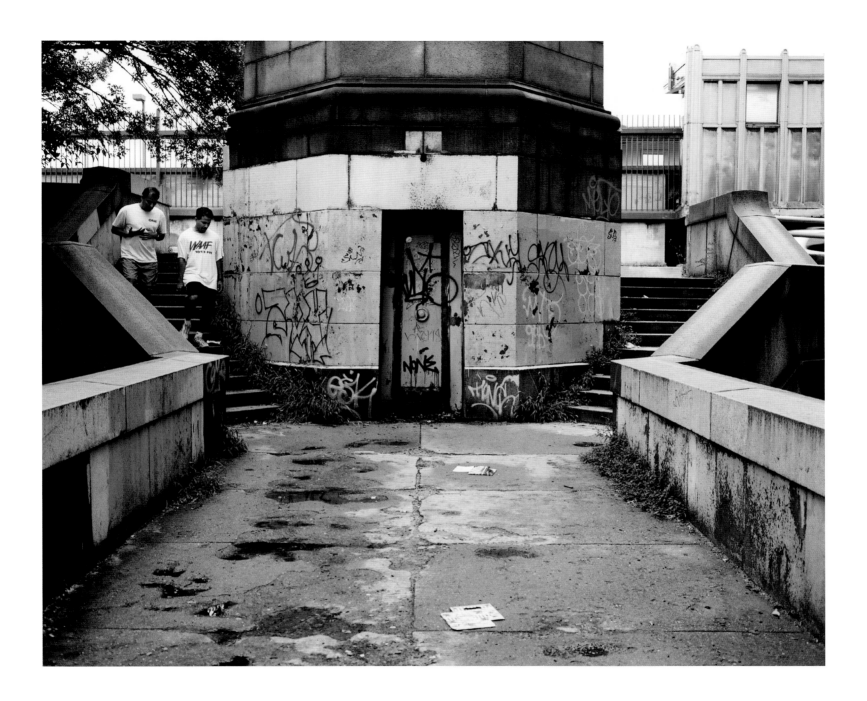

The clue read, "Walk off the end of the wooden plank and keep going straight. Little kids can't reach it." But there was no wooden plank. Maybe the plank is seasonal—part of a see-saw or jungle-gym that had been dismantled.

In such moments, I try to imagine geocaching is a kind of mindstate, tell myself that it is possible to reconstruct the owner's inspiration. In this old urban park in **Louisville, Kentucky**, the arched bridge held my attention. After a few minutes of staring, I imposed a pretend pirate's plank, considered where a Captain Vere might order a dismayed mate overboard. From there, I kept going straight. And, instead of facing certain doom, I spied the hidden treasure peeking out from beneath the ivy-coated stone.

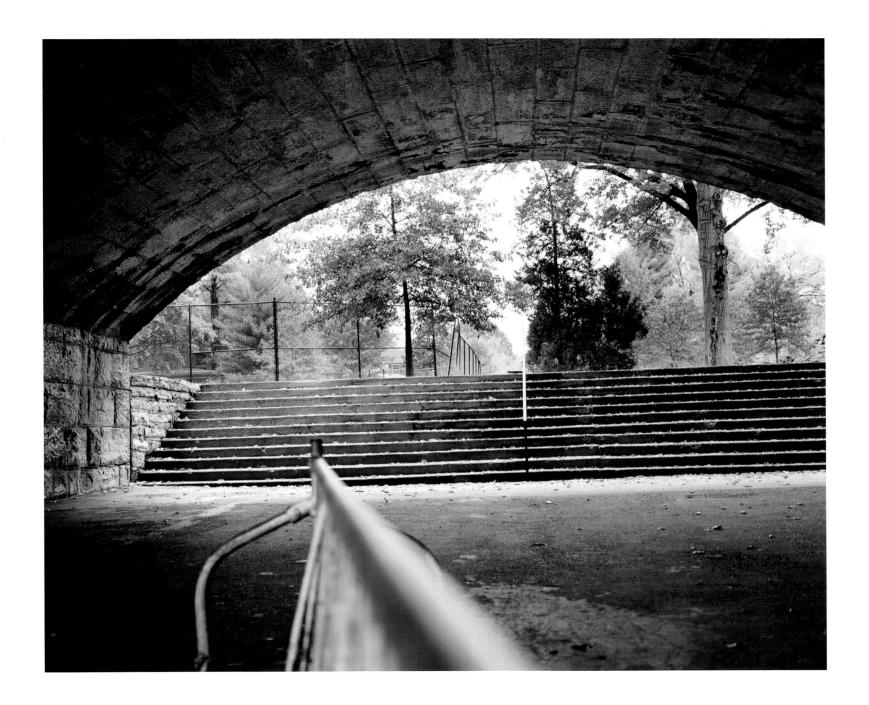

I'd been here once before, in autumn, stopped back on a trip north because I thought this historic park in **Kittery, Maine**, would be even more beautiful in snow. I hadn't counted on how deep the drifts would be. As a child, I'd invented tricks to stay atop the snow, thinking to defy physics by half-walking, half-gliding, so as not to break the crunchy surface. The world those days seemed doubly new—the snow clearing away details, my added height allowing me novel sights. Apparently snow isn't as well-made as it used to be, for this day I sunk frequently, often to my hips, before leaving Fort McClary a bit colder and wiser than I'd arrived.

American geocachers have an acronym for going to a cache and not making an exchange: TNLN, they write in the logbooks, "took nothing, left nothing." I'd have written that phrase if I'd reached the deeply buried logbook, would have added a few lines from Wallace Stevens's poem "The Snow Man" that the blank expanses of white had called into my head: "One must have a mind of winter," he wrote, "and have been cold a long time" in order to see winter as winter is, in order to become a "listener, who listens in the snow, /And, nothing himself, beholds /Nothing that is not there and the nothing that is."

Because sometimes on a clear, cold day, the rules of math come undone, and the sum of many nothings is suddenly something. Something huge.

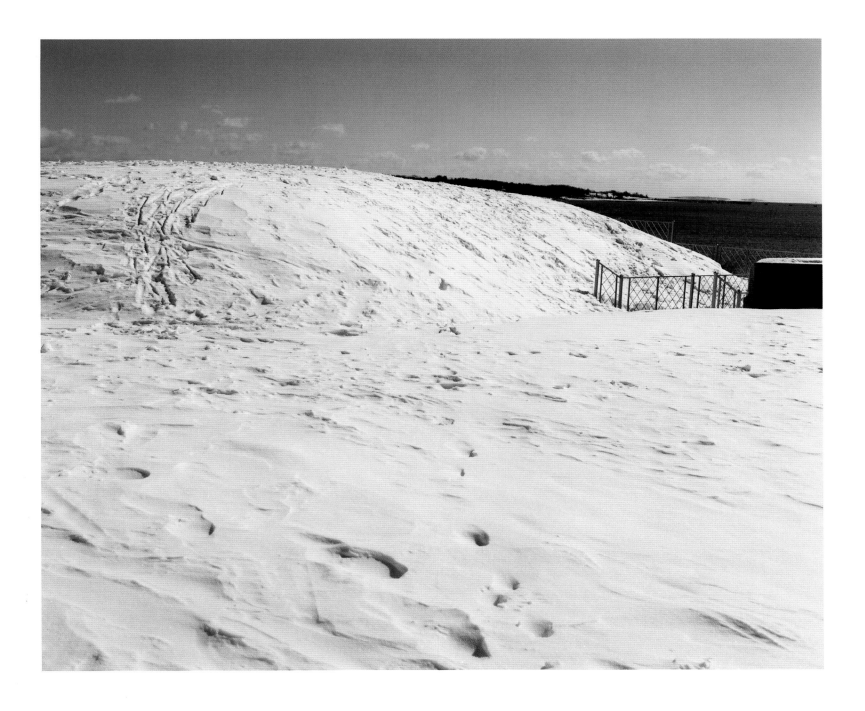

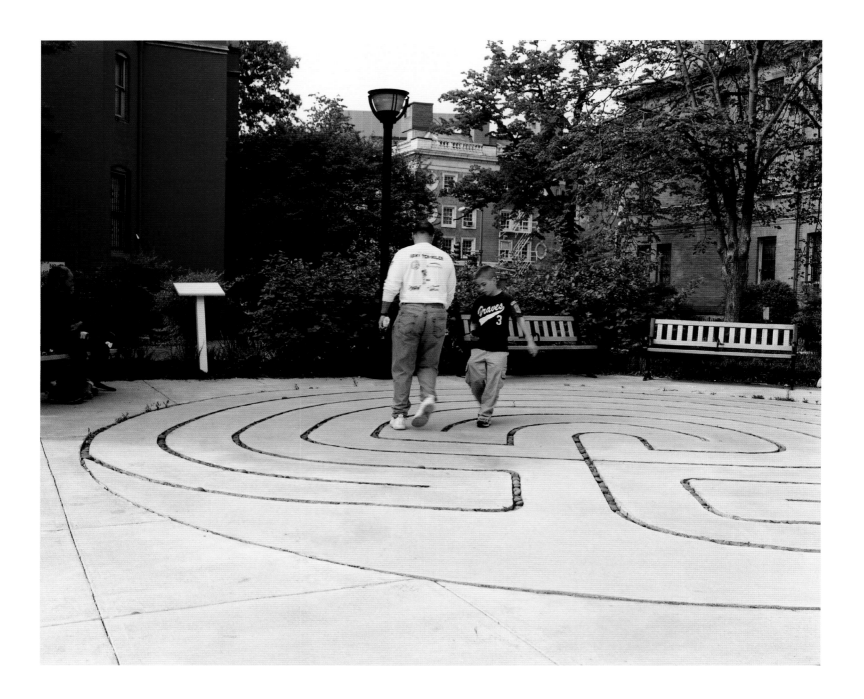

In the martial art of Aikido, the true warrior strives not to harm opponents. Indeed, warriors train less to fight than to create conditions within which battle need not take place. In rigorous practices, students and sensei take turns attacking and defending; perpetually alternating roles, they cannot help but remember that each is only momentarily the inverse of the other, that each also is the other, beings conjoined in a seamless universe.

My friend, Janet, and I were in **Washington, D.C.**, waiting for my brother, Tom, and his son, Nathaniel. We were going to geocache awhile; then Tom would take us on a tour of the Pentagon, where he works. I wanted to see his new office, but, more than that, felt the need to see where his old office was—before a hijacked plane destroyed it on 9/11. When Tom and Nathaniel arrived, we set out to find a virtual cache, a labyrinth in a peace park that members of St. Thomas Parish created after an arsonist destroyed their church. They made a place where violence could be acknowledged, but where peace and reflection would prevail. Spotting the labyrinth, Nathaniel dashed to the middle of it. Tom gently explained to him that at a virtual cache there isn't a box of toys, that the experience is the prize. Nimbly, he steered his son away from disappointment, and they walked the labyrinth together. Nathaniel was puzzled at having to zigzag when his destination was right in front of him, but he played along, humoring the adults.

When we finished caching, we went to the Pentagon. At the entrance, Nathaniel asked about the row of cement blocks filled with dirt that we passed. Tom explained that they prevent trucks from crashing into the building, added that sometimes people plant flowers in them. Even inside the intensely guarded buildings, Tom held Nathaniel's hand—just enough to keep him close, not so much he'd feel obliged to try to pull away.

This part is embarrassing for me to admit: I chose the peace park geocache quite concertedly. I feel beset by America's bellicoseness, and inviting Tom to go there before going to the Pentagon seemed clever, wry—like a postmodern David tweaking a representative of Goliath. But now my gesture seems small. For, on this day, I recognized in my brother the spirit of a true warrior. And I could see that he does not need my reminders about the importance of peace.

Every once in a while, I get to a cache and the place disappoints because it feels unsavory or is full of trash. This time, though, we're looking for trash—knowingly, eagerly heading to a place the cache owner touted for its dumpiness. He told folks right up front that "Hutchinson Island has been Savannah's dumping ground for ever. Not only were parts of this island used as a dump for a while, it has also been used as a dumping ground for dredge spoil." Tantalizing as that sounds, it probably wouldn't have drawn me, but the cache owner went on to say, "You may find old bottles, gold, silver, jewels, eighteenth-century clay pipes and assorted flotsam and jetsam along the nearby river banks." Although I did not expect to find gold and silver, I did think I'd spot shards of pottery everyone else had overlooked. I'd even have settled (quite happily, in fact) for a piece of an old plate.

Such was not to be. The island sitting **between Georgia and South Carolina** wasn't nearly the dump we counted on. Sure, we saw some junk, but **Hutchinson Island** has undergone a massive facelift. Now, it is home to an auto race track, an $83.5 million convention center, and a $98 million resort complex. To reach the "unimproved" end, where people go four-wheeling and where the cache was hidden, we passed lavish hotels and a deep-green golf course.

But beneath this peaceful luxury lies that century or more of rubble, in thick layers of lost stories, detritus that cannot drift away, that shall surface again someday.

I'd been geocaching for about a year before my father joined me on a jaunt. Needing a new hip, he'd been unable to enjoy walking on uneven terrain for years. But last fall, he got his hip replaced, and the new joint seemed like a modern miracle—a slim bit of titanium able to grant him new mobility.

So this spring, when the snow was entirely melted and his physical therapy was officially over, he, my mom, and I went to a cache in **Bolton, Massachusetts**, just a few miles from their home. It promised a magnificent view, remnants of an old powderhouse, and a short walk. Since this was to be his first trek on anything other than a flat track, that last item was important. I was excited, but as we walked my enthusiasm waned; I'd forgotten that the distance a GPS describes is "as the crow flies." As we walked and walked, up and down, over leaf-slipperied trails, I could tell my dad was tiring. I proposed turning back, but he brushed aside the idea. By the time we reached the cache, it was clear we'd come too far. And, of course, we still had to walk back to the car.

Partway back, my mom spied a snake basking in the sun. She picked up a stick and started to poke it. Chidingly, I reminded her that she was old enough to know better than to hurt defenseless creatures, and certainly old enough to know better than to taunt dangerous ones. Whatever sort of snake it was, I pressed, didn't she think she should leave it alone? She blithely ignored me.

I waited self-righteously until she gave the snake a last nudge and resumed walking. Following a few steps behind my parents, I saw my mom gently squeeze my dad's side, and realized all that poking and prodding had been a means to make a moment for him to rest—without his having to ask for it or accept the offer of it. I recalled the story of God transforming a walking stick into a snake and back again, a miracle for Moses to prove that God had spoken to him. I'm not sure my father knows his wife performed much the same miracle, albeit in reverse. More inspiring to me is that he doesn't need to.

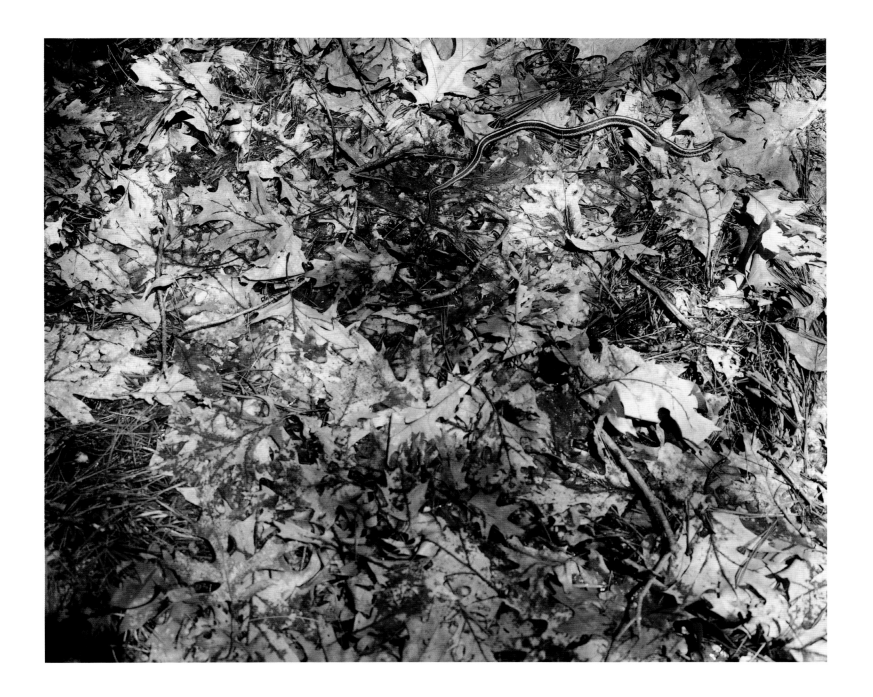

The extensive park system in the United States is, to a remarkable degree, the result of chance Roo-seveltian double-teaming. At the beginning of the twentieth century, Theodore signed legislation to establish five parks, and paved the way for a host of others through the "Antiquities Act," by which the president could proclaim "historic landmarks, historic or prehistoric structures, and other objects of historic or scientific interest" as national monuments. Thirty years later, Franklin D. established the Civilian Conservation Corps (CCC) to create jobs for unemployed men during the Depression. Many worked in state and national parks—building roads and bridges, creating and improving trails, erect-ing cabins and lodges.

In **DeSoto State Park, Alabama**, this heritage is proudly recalled. Reading about the "CCC Quarry Cache" located there, we learned that the park built by the young CCC workers between 1935 and '39 was then the largest in Alabama, that it is the site of an annual CCC reunion, and that many of their projects endure, ranging from the roads themselves to the cabins that vacationers could rent for $2.25 a night, sixty years ago.

We followed the White Trail to the quarry where they'd harvested stone for some of the larger proj-ects—an easy scramble past gargantuan rocks and delicate lady slippers. Twice, the trail overlapped a fresh road cut for a few yards before veering back into the woods. I imagined the CCC men would have been mighty keen to have the machines their successors were using to clear this red swath through the trees. But it felt too raw to me, like a wound; I preferred it when the trail curled back again, when we were lost in the golden sheen of spring, interlopers among ancient rocks and infant trees, the green world the Roosevelts bequeathed in wise legacy.

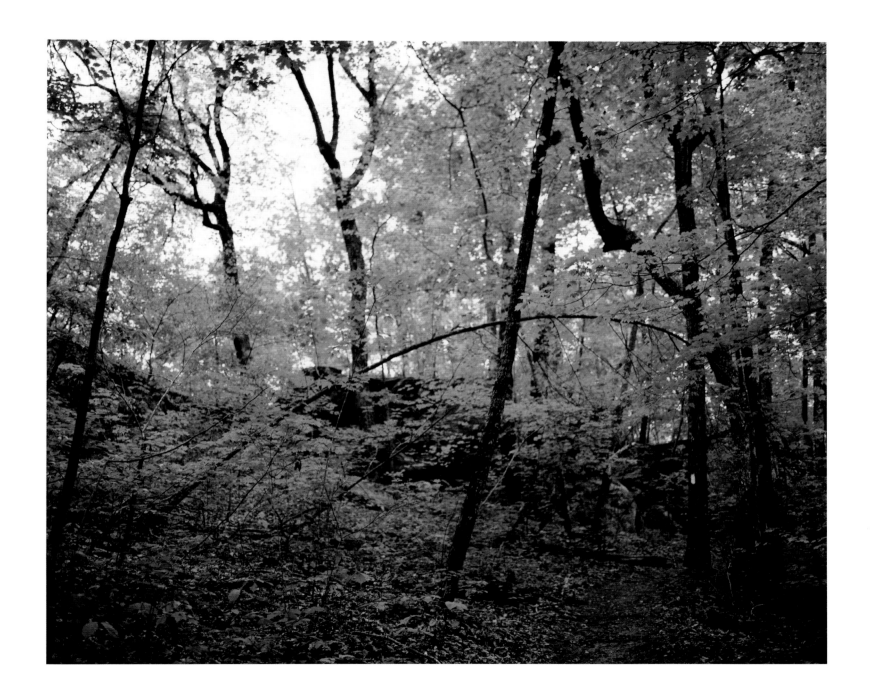

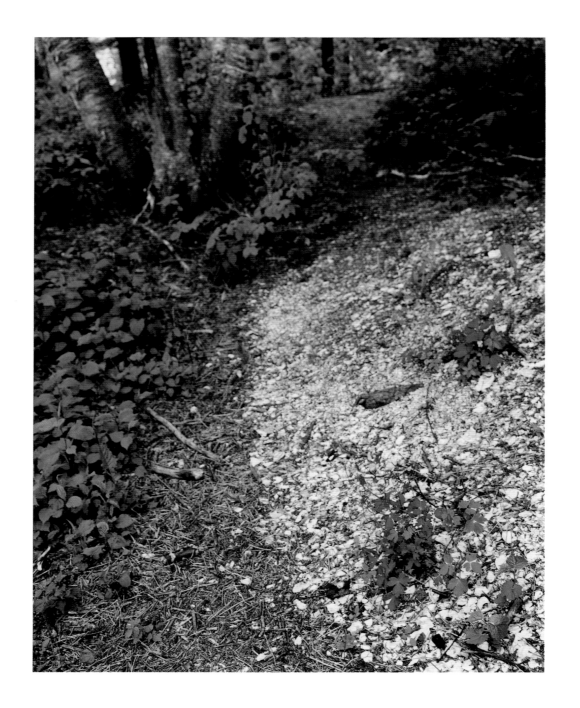

Over the last century, telescopes have gotten larger and better. Now, those who search the heavens for intimations of what the universe has been can look farther back than ever before. For looking into the sky, they say, is more properly thought of as looking back in time rather than looking out into space. We see traces of long-ago light, twinkling evidence of a moment that was, one that's still expanding.

I like this notion, that scientists measure the distance between us and stars not in kilometers but in what they call "look back time." Not infrequently, geocaching encourages me to do something simi-lar. On this day, we stood near the **Damariscotta River** in **Maine**, swatting away monstrous mosqui-toes, while we sifted through thick oyster shells, trying to find one that is whole. The hillock they form—punctuated by columbine—resembles nothing grander than the crush of white that some-times decorates a yard in the south. A sign explained that this small heap is all that remains of a pair of once-immense middens, the largest north of Georgia. Shells had been mounded high on both sides of the river by oyster-harvesting tribes who lived in what is now Midcoast Maine. Industrial need diminished these calcified hills, which were harvested for lime during the nineteenth century. I was glad to see what's left while it's left, to touch shells that housed a meal eaten by another person cen-turies ago. I was surprised to be this moved by what is, technically, very old garbage.

We found the midden as we find most caches, using GPS receivers that gather signals emitted by satellites orbiting far above Earth. The signals embed a time stamp, and, by comparing the times when four signals are emitted, the receivers calculate their own locations precisely. It takes just moments for the signals to reach the geocacher's GPS, barely a cosmic blink. In that tiny while, I often think we are walking the same path as a host of unknown kin with whom we share at least one pleasure, a delight in espying greetings between future and past, hellos stilling to a now, in awe-filled recognition.

In "Directive," the American poet Robert Frost invites readers on a trip:

Your destination and your destiny's
A brook that was the water of the house,
Cold as a spring as yet so near its source,
Too lofty and original to rage.

I love this image of waters near their source, the saturated atmosphere resolving to liquid where a stream begins. Looking for a cache at the **Upper Falls at Graveyard Fields**, off the Blue Ridge Parkway in **North Carolina**, I climbed down into the fields and then up, ducking through tunnels of enveloping green, on my way to the top of the falls. Two guys playing hooky from UNC-Asheville arrived at the same moment I did. They offered me one of their Nalgene bottles to collect some water. As it turned out, I didn't need it. Instead, we all squatted gingerly at the head of the falls, scooping handful after handful of shockingly cold water, indifferent to giardia, glad to drink from a brook before it raged.

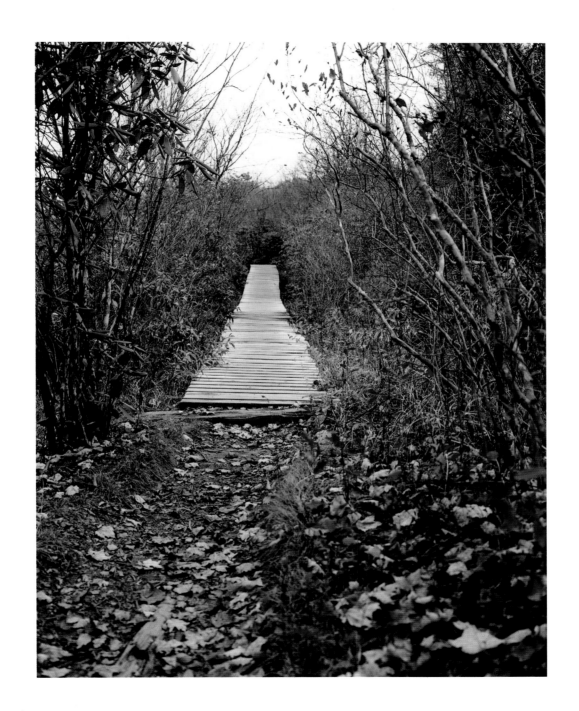

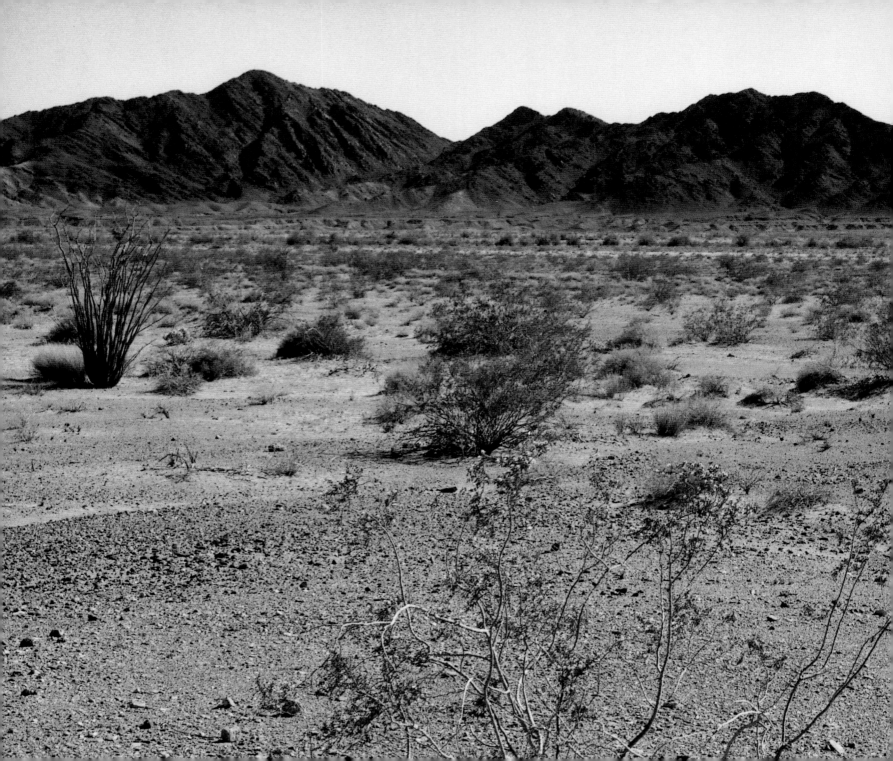

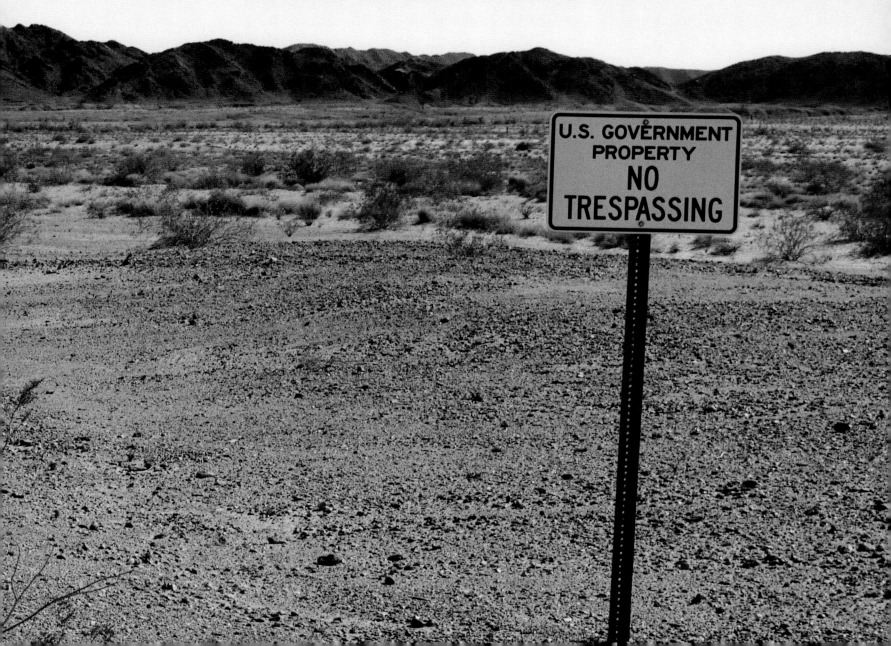

PART IV: OTHER PLACES

I left a camera in a cache near **Lake Erie**, in Huntington Reservation, which is part of the **Cleveland, Ohio**, Metropark System. Just before Christmas, the cache owner contacted me; he had to remove the cache and wondered what to do with the camera. He said he'd be making a new cache come the new year. I wrote back, asked him to put the camera in the new cache, and took the opportunity to ask him why he geocached. This is the e-mail he sent back:

Margot,

I always enjoyed getting outside and geocaching fits with the other activities I enjoy. I go dayhiking or birding nearly every weekend that my schedule allows. It helps me get away from the boring corporate America job that occupies an overly large percentage of my time.

I saw an article in a magazine about geocaching and thought I might check it out someday. Then I promptly forgot all about it. A few months later the Cleveland Metroparks had an introductory program and I decided to attend. A geocacher was born. Almost one year and 100+ caches later, I'm stuck doing the road-trip thing to find new caches, as there's nothing left locally. It's a great hobby. I've been to some beautiful and interesting places I would have never visited and, through the Northeast Ohio Geocachers club, I've made some new friends. I'm a volunteer for the Cleveland Metroparks and this has allowed me to work with the parks on caching policies and to meet with other parks districts to try to get caching allowed in their parks.

I'll get the camera back in circulation shortly. If I get my wrapping finished today, I might even have some free time tomorrow.

E—

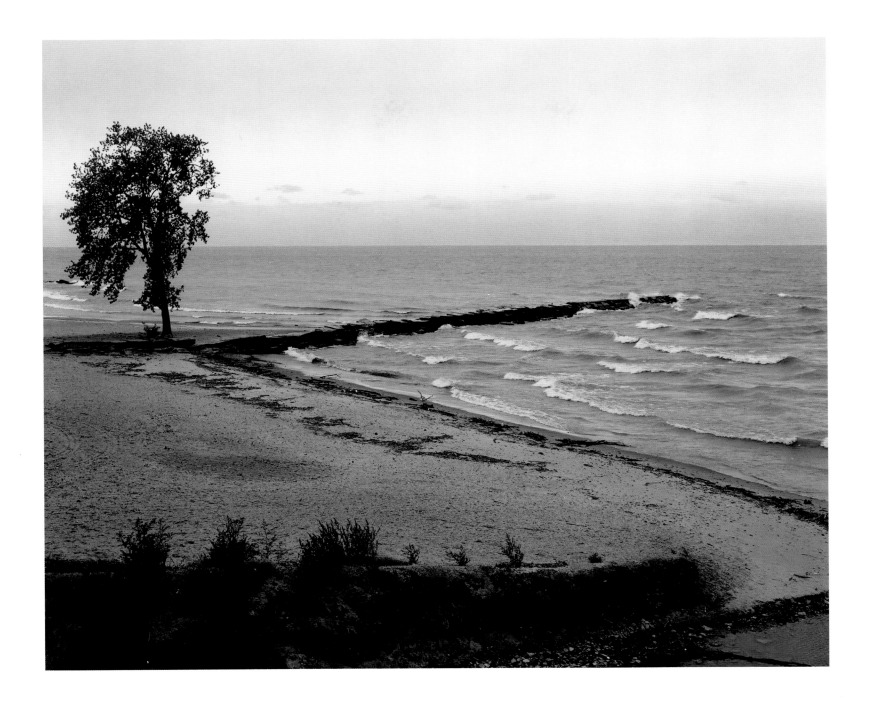

In January 2002, two astronomers at the Johns Hopkins University announced that the universe is light green, specifically a few percent greener than turquoise. In reaching this conclusion, Doctors Karl Glazebrook and Ivan Baldry began by plotting the wavelengths of all the visible light in the galaxy, based on intensity, on a single chart. Then they converted those intensities into the colors that the human eye would perceive at a given wavelength. When they averaged the results, they got green.

One reason this interests me is that the color of the universe is time dependent. When this universe was younger, it was likely bluer. As it ages, it will become redder. A week or two later, I heard a brief retraction of the claim one morning on National Public Radio. The new announcement claimed the universe is not green, but beige, that the earlier results had been marred by computer error.

I reject this new claim. Walking through **Ridley Creek State Park, Pennsylvania**, on a misty Earth Day afternoon, I know my universe is still green.

I've hurried away from only two caches because I was afraid—one in Kentucky and one in Virginia. In Kentucky, it was a perverse form of politeness, really, a reluctance to be somewhere I knew I wasn't welcome. But on an unpopulated mountain near **Roanoke, Virginia**, I ran clumsily to my car, cold with the conviction that someone I couldn't see was watching me. I left that spot as fast as I could and drove a few miles to find a cache hidden behind this elementary school's playing fields. As I searched, I felt comforted by children's laughter and chitter-song, the swell of sound peculiar to grammar school recesses.

This morning, my brother e-mailed me an article about how GPS technologies are being used to monitor and control movement. Using a GPS that's worn by—or implanted in—a prisoner, police can track that person's movements. Hospitals can make sure Alzheimer's patients don't wander too far. Parents can know their kids made it to school, or are safely on their way to a friend's to play.

I think about how seeing and being seen are not each other's inverse, about how a benefit and a detriment almost never sum to zero.

N 37° 14.931 W 079° 58.534

Sometimes I get lost when I geocache—though it's a curious kind of "lost." I always know exactly where I am, for the GPS provides continuously updated latitude and longitude readings. And I'm never more than a few miles from where I leave my car. Still, if I forget to note the coordinates of that location, it can be hard to find when I'm ready to head back. Then I have to remind myself that I really do agree with Henry David Thoreau that it's a "valuable experience, to be lost in the woods any time." In **Cleveland, Ohio**, on this day, I got ridiculously off-track, eventually exiting the park through someone's backyard. I ended up asking a postman the way. He gave me perfect directions, telling me not only where to turn, but also how many houses to pass on each street, ticking them off by house number on his fingers to be sure. His directions added several miles to the distance a direct route would have taken—but they got me to my car without further confusion.

Complexity theorists talk about a behavior of cellular automata called a "random walk." Investigators program these automata with simple rules. One of the simplest ones is: for each iteration, the automata moves one step to the left or one step to the right, the direction determined by whether or not it has a neighbor. Such behavior is deterministic (that is, following a predefined rule) and yet unpredictable. No one knows ahead of time what the path of a given automata's random walk will look like.

But here's the cool thing: if one lets these simply programmed automata walk for long enough, continue their journeys for millions of steps, then their paths *always* end up making a complete, filled circle.

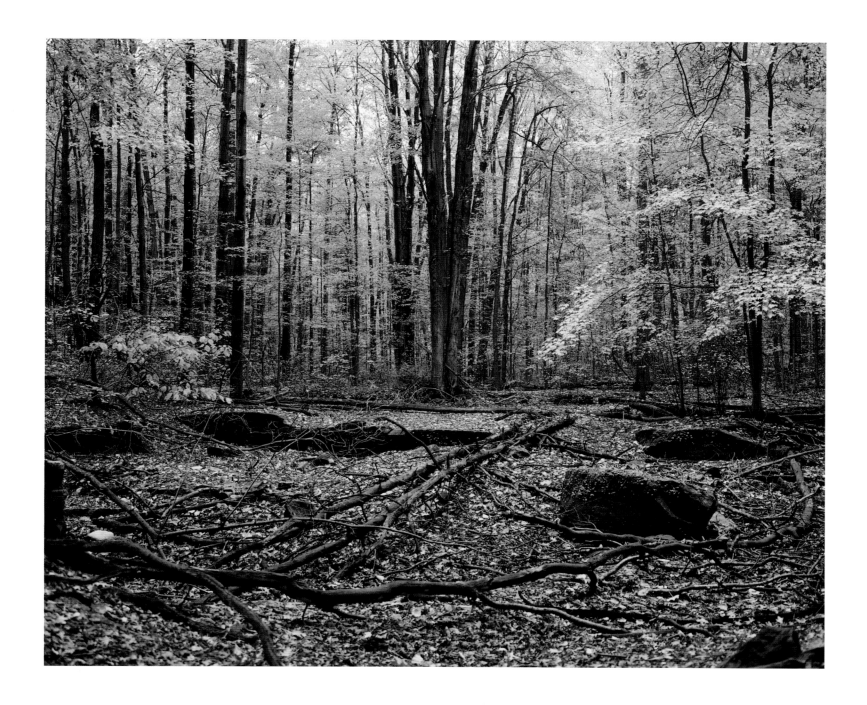

While I sat in the dry nook beneath a small, cascading waterfall in the **Pisgah National Forest** in **North Carolina**, two young mothers arrived, pushing baby strollers through the woods. They got out the makings for a picnic, then took each of the toddlers by the hand and helped them come in under the red rock outcropping. Together, they stood a few inches back from the sheet of water splashing down. Once the little ones got their bearings, their moms helped them reach forward to catch some of the streaming water, and they washed their hands for lunch.

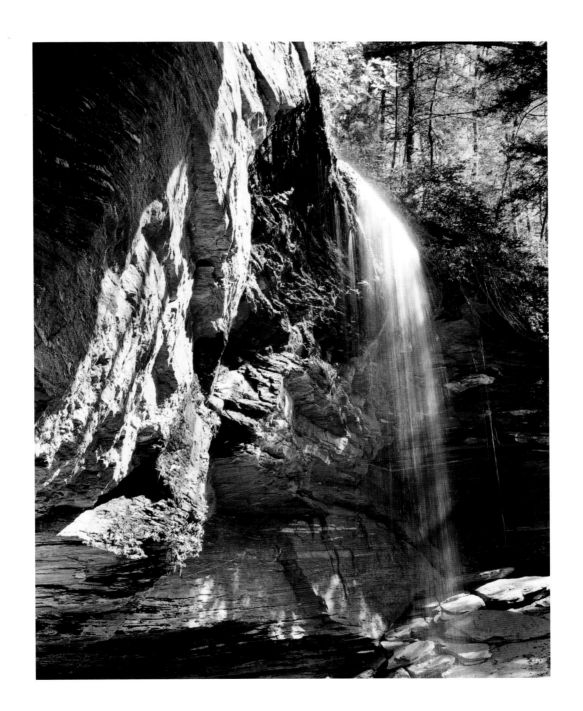

Learning to walk while navigating by GPS is like a geographical version of becoming conscious of being conscious: you flip back and forth between noting the representation of the territory that you're making and observing the territory itself, like that here in **Nevada**. Then you notice you've been missing the territory you came to see because you've been so caught up in looking at your abstracted version. So you concentrate on the world around you for a while, forsaking the information the map provides until something . . .

usually exhaustion because this three-, maybe four-mile walk has extended into a many-mile venture and the end is not yet in sight and you think that, if only you could cut across these red stone hills, then maybe you'd be able to get back to your car before dusk, and you wish you'd known to pay attention to altitude readings, but they'd seemed trivial when you were looking at the description—it's the desert, after all, and you thought the desert was flat—and now you know that none of it is trivial and that the desert isn't flat, and you hope that you'll make it back to the car to tell your friends these new realizations, and, though you recognize that thinking such things is melodramatic, you can't quite quit thinking them

. . . makes you remember why you found the map so useful in the first place. Eventually, you learn to balance this to-ing and fro-ing into a graceful pattern, a rhythm, by which you are able—often, and with pleasure—to know where you are and to be there.

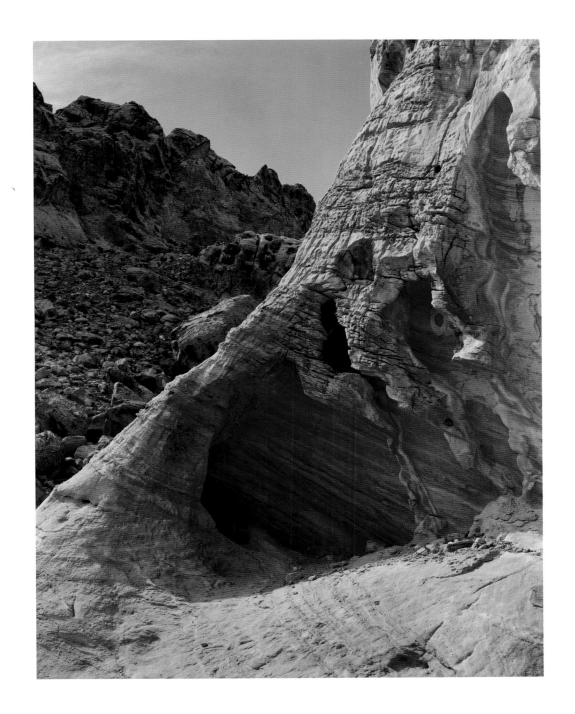

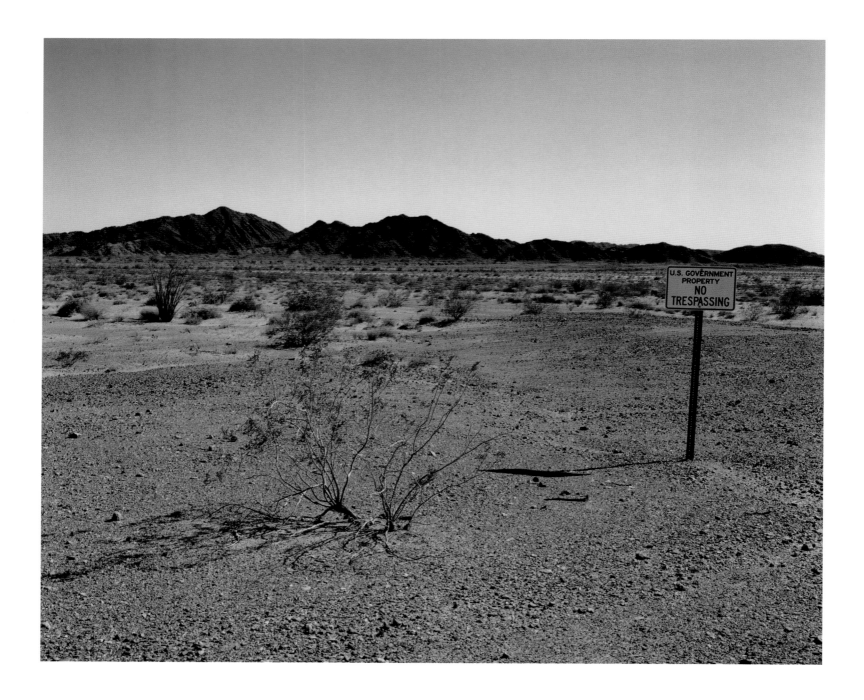

In the moment, I felt puckish, even a little smug. Technically, it's a federal offense to geocache in this place in **Arizona** (hence the X'd coordinates), a violation of one of the prohibitions the government has issued related to the game. I understand the necessity of bans in certain places, but often the prohibitions seem so unnecessary that they smack of tyranny. When Rob and I realized this cache was in forbidden territory, we thought carefully about what to do. We decided to stay, to consider this foray an exercise of civil disobedience.

That was then, before I began trying to identify the name of the mountains in the distance. I Googled the location and in .85 seconds was able to start sifting through a few of the 11,000 Websites the search engine gathered. One was a link to the official Website of the place we'd been; naturally, I clicked on it. A warning appeared: I was about to enter a Department of Defense (DOD) computer system. Still miffed that the DOD dots the desert with *No Trespassing* signs, I briefly considered clicking 'okay' and entering the military's virtual dominion. But the notice also said that entering the site constituted "consent to monitoring" my computer, permission for "active attacks by authorized DOD entities" against my peaceable, unassuming laptop. I decided topographical curiosity was insufficient reason to risk "administrative, criminal, or other adverse action."

I'd like to say I'm simply sulking, mortified by my quick compliance with the warning, afraid it means I've negated whatever high-mindedness I exhibited in the desert. But the queasiness I felt as I read that cybernetic "do not enter" sign seemed less a symptom of petulance than of grief. I felt overcome by public sorrow, oppressed by the knowledge that the government owns forty-two percent of the land in Arizona and denies us access to much of it, that it can *already* search my computer, without even waiting for me to click "okay," that both land and broadband are now places to be entered at one's own risk, subject to penalty, after consenting to be monitored.

I found my way to **Churchill Downs**, where the parking lot attendant gave me a free ticket to the races. She was kind, to be sure, but also doing her part for the track. Although a fair portion of the 12,000 Future Farmers of America who had converged on **Louisville, Kentucky**, the night before seemed to be here, I spied very few others inside who looked old enough to place a bet.

The Future Farmers were having fun, and I eavesdropped on them as I passed each clique. Some were talking about the horses, or about how cool it would be to bet or to be here for the Kentucky Derby. One boy was practicing lassoing, to a mix of jeers and admiring grunts. Most of the girls, by far, were talking about boys—whispering, pointing, giggling, poking each other—as each new guy walked by. When the third race was announced, though, everyone (even the girls) turned toward the track, quiet attention focused for the scant minutes it lasted, cheers erupting when Cha-ching Cha-ching won. When it became clear it'd be a while before the fourth race began, I decided to hunt for the cache.

To my surprise, it was outside the park. So, with a wave to the kind lot attendant, I walked away from the track as well as from my parked car. A tall stone wall separated the manicured racetrack from the now graying city. Halfway down the wall, a film canister holding the cache log was tucked into a crack in the mortar, behind dead ivy, just below the eagle's nest.

The levee was dry. Full of lush grasses, but without any hint of the grid of pseudo-ponds I'd expected. Although the deep green was lovely, I was disappointed to discover that a dry levee looks pretty much like an extremely oversized football field. I guess I was a little chagrined, too, because it hadn't once dawned on me it might be dry, even though Janet and I were (somewhat predictably) singing "Bye, bye Miss American Pie, drove my Mini to the levee but the levee was dry" as we navigated through **Chattanooga, Tennessee**, toward this cache.

Such disappointments are—eventually—one of the things about geocaching for which I'm most grateful. True, I have to *remind* myself how grateful I am, because each time it happens I feel foolish that it's happened again. But, after the initial dissatisfaction, I feel lucky. Lucky that it's such a gentle comeuppance, this reminder from the universe that the world is what it is. Lucky to be bopped on the nose so lightly and yet so obviously, by having waving grasses whisper that, if I hadn't gone to the levee with a host of expectations, I wouldn't have felt disappointed. Lucky to be given a second chance to recognize that this verdant space behind a sorely aging school, so unlike what I'd imagined, simply is what it is, and is beautiful for that.

N 35° 01.643 W 085° 12.828

Though we trod carefully, shuffle-stepping from tie to tie along the abandoned tracks, we still startled the deer. Obscured by the thicket separating park from neighboring farm, in the no-man's land of an untended railroad easement, they were completely invisible to our unpracticed eyes until the moment they bolted. The cache, in contrast, was easy to spot—hidden where bridge becomes embankment—so folks afraid of heights need not brave the trestle. It looked perfectly sturdy to us; so, while Gina explored, I sat at the middle of the bridge, many meters above **Split Rock Creek**, listening to the air.

Too soon, my mind wandered. I imagined what it was like here in **South Dakota** when railroads first crisscrossed the nation. I pictured a few houses, maybe half a dozen. Then, the railroad company lay new track. The settlement became a village; the village turned into a town. A brilliant white grain elevator beside the tracks stood as a symbol of how well everyone was faring. A few of the wealthiest citizens bought automobiles. Pretty soon, many folks had them, and they began clamoring for better roads. Eventually, the roads were paved, expanded. Train travel grew less popular; the railroad company reduced—then discontinued—passenger service here. The general store failed. Vacant houses, slumped into their cellars, were reclaimed by the earth; perhaps they are beneath the grassy hillocks we've seen, so smooth and curiously spaced. The hills were lovely, low, and sweet; even so, I felt sad for the loss they signify, astonished by the depopulation this part of the nation continues to experience even as the coasts grow more and more congested.

I know this is how it goes, that communities, like people, are born, live a while, then die. That everything from quarks to civilizations winks in and out of existence. That making myself unhappy about the rise and fall of imaginary towns is silly, unskillful. But knowing did not make me less crestfallen.

What did was a tremendous splash below. I'd been so lost in reverie that I crossed the trestle too slowly to see what made it. That missed opportunity roused me. I didn't suddenly forget how transitory everything is, but I did remember where I was—that I was perched halfway between the shores of an ammoniac creek where life persisted against great odds, between earth and sky on a sun-warmed bridge that did not sway. I wanted to see whatever this unlikely vantage might reveal.

Old men playing dominoes in the park, a strangely languorous woodpecker fretting a dead oak tree, a thousand three-year-olds playing croquet. I sat on the ground near **Manoa Falls** in **Honolulu, Hawaii**, amid so much bamboo I had to hug my knees tight to fit between the thick stalks, listening to wave after wave of its delicate clatter as the wind washed through this lush place. *I have fallen in love with a sound*, I thought, wanting to find a way to describe it, to share the idea of it, the feeling it evokes. But none of my comparisons convey the hushed counterpoint, the susurrus of young leaves in a high canopy, like the sigh to which satin aspires. *It's how peace would sound if it made a sound*, I decided.

Giving up on these analogies, I tried instead simply to spell what I heard, to hold it in phonemes. But nothing quite fit. Later, that night, as I was drifting to sleep, the spelling that wouldn't come in the bamboo grove arrived, suddenly obvious. Testing it aloud, I listened to the syllables rustling against themselves, occasionally harmonizing with the whispers of the sea, as I murmured the ancient word for deepest peace: *shanti, shanti, shanti.*

The cache description promised a lovely creek and a high-voltage fence, and we found both. I fought a perverse desire to touch the fence, curious to know how strong the charge would be. We couldn't guess a reason for it; the adjacent land looked like acres more of the same, and the biggest animals we spied were sun-haloed jackrabbits no fence could stop. They convinced me, with a logic perhaps as perverse as my earlier longing, that the jolt would be considerable.

Even more curious than a deadly, unnecessary fence was a creek filled with trees. I'm from a part of the world where trees grow in soil or cling to rock; but here in **Cibolo Nature Preserve**, in the Hill Country of **Texas**, a large and obviously aged arbor rose from the water. I know now they are bald cypress, not as out of place as I then supposed, that they grow in marshy places, and that the stubs dotting the stream's surface are their knees, knobs of root wending airward to help them breathe.

But that day, with dusk approaching, fence and trees strained our understanding, and I imagined we'd stumbled down a jackrabbit's hole into a jade wonderland, a world limned by light that glanced off trees, off water, off wire, filled with smells so sad they made us ache. And I hoped without hope for a cache brimming with *eat me* cakes, or *drink me* vials, or some other something that might let us make some sense of it awhile.

N 29° 46.508 W 098° 42.498

Some time ago, I brought the students in one of my literature classes to a nearby woods for an early morning walk. We were studying Transcendentalism, and I wanted them to have a chance to glimpse the day as Ralph Waldo Emerson described it, sublime despite its ordinariness. Afterwards, when we were talking, I wondered aloud how one might come to greet each moment with the freshness of that American philosopher, to be present fully to the everyday world. A quiet guy raised his hand, a gentle smile framing his tentative answer—"Amnesia?" he proposed. I will love him for that long after I forget his name.

It isn't amnesia, but perhaps a fear of amnesia embodied as a kind of preemptive intervention, that I've noticed of late, for often I find caches at "historical" sites. Chronicles of battle on placards by the parking lots, walls of forts, homes that garrisoned troops, even concrete bunkers from World War II—such as one at this park near **Portsmouth, New Hampshire**—are now attractions. The remains of a bellicose past are sometimes obscured by new growth, countered by the whimsy of forsythia, adorned with graffiti. But these are our saved places, the memories of record.

As happy as I am to discover middens or petrographs or fossils, I realize I am not especially interested in visiting this kind of officially conserved past. I'm not sure why. But I am sure it's less pressing to me to remember that this place was part of New Hampshire's coastal defense for twenty years than to recall that, one gusty April day, I discovered—beneath a broken branch still moored to the tree that was its living past—a small box containing a chicken bone, a deck of cards, a baby doll's leg, a rubber spider, and a dollar bill.

Pauli's exclusion principle states that there can't be more than one electron in any given quantum state. It's often paraphrased as *no two things can be in the same place at the same time*, which seems both straightforward and quite sensible. But, if you think about it, you probably know the translation's not true.

We knew we were close to the Revolutionary War Ruins Cache in **Thornbury Township, Pennsylvania**, hidden near the remains of the house of a woman named Polly Frazer. With her husband gone to war, she'd defended herself and her home against marauding British redcoats. So, despite rain, we headed down a railbed, over tracks so close together we knew they must have carried transcontinental traffic before they began transporting suburban commuters.

We turned into the woods, onto a new trail. Staying to the newly laid mulch was more treacherous than following deer trails would have been. And there were deer paths—and plenty of deer. Three of them appeared each time I suggested to Rob that the thickening rain was a sign we should go home. The deer were young, white-tailed, standing just at the edge of sight, always in the direction we needed to go. I'd like to think they were helping us. It's true even if it's not true.

When we were within 200 feet, we found ourselves on the edge of a development of trophy houses. No more deer. I doubted our coordinates, for they led us over a newly planted lawn—the waffles of turf so raw they hadn't yet melded with the base soil. But a dozen steps later we spotted a wide path that reentered the woods and led straight to the ruin.

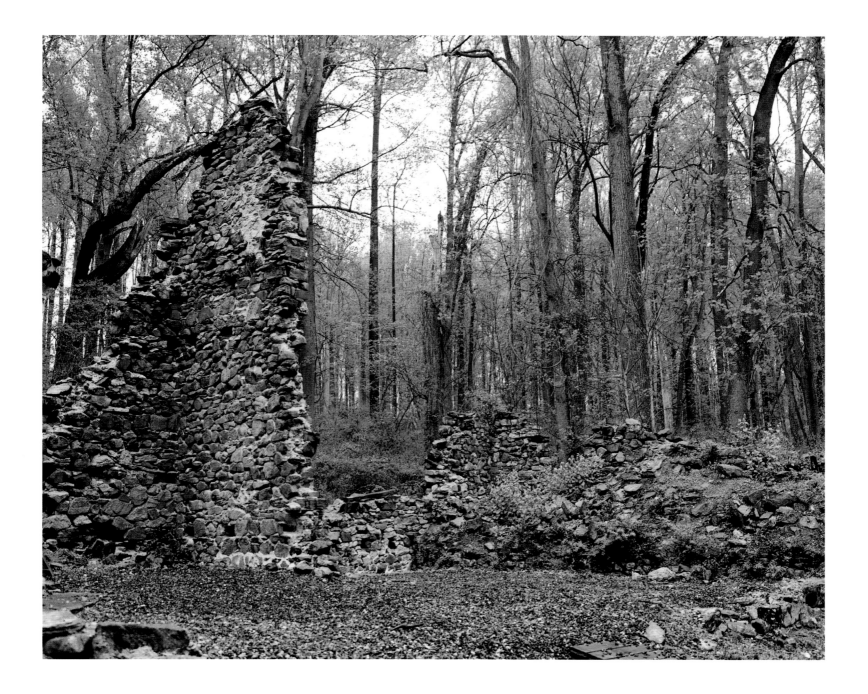

We had traveled for more than a week, from Pennsylvania south to Tennessee, over to Florida, then up Interstate 95. On May Day, the last day of our trip, Janet and I wanted to find a cache that pays homage to the surveyors who long ago drew the Mason-Dixon line. When we planned the trip, it seemed like a fitting culmination. During the trip, it became all the more so, as we were reminded how deeply divided America is, still scored by the cultural rifts this line has long signified.

On our first hike, Janet mentioned she was keeping an eye out for jack-in-the-pulpit, a plant she remembered from childhood walks. It's a spring ephemeral, distinguished by a wide, green leaf, gently folded over, and quite hardy. Individual plants survive, in part, by being able to change sex as conditions demand (an adaptability that impresses me). So it should be odd that Janet hadn't seen any in years, that we didn't see any all week.

But it's not. Development in the eastern U.S. is quickly transforming woodlands into suburbs. And while deer and fox hover in leftover woodlots, eventually creeping closer to backyards to look for a home, jack-in-the-pulpit can't actively seek new terrain. Many woods still harbor spring ephemerals, but they're being depleted by thieves. Like the infamous "orchid thief" who inspired a novel, these bandits harvest wild jack-in-the-pulpit and trillium—selling them to unsuspecting or indifferent nurseries.

At mid-afternoon, we headed for the "post mark'd west" which starts the Mason-Dixon Line. We followed a thin trail from a **Delaware State Park** parking lot, through a meadow into the woods. Soon, we were to find the cache nestled into the base of a tree that had split in two early in its life, becoming a pair of trunks diverging mere feet above the ground. But before we got that far, we enjoyed a simpler delight. Scant steps into the woods Janet spotted a jack-in-the-pulpit. Then another and another. The plants were everywhere—so many that in some spots we had to tiptoe to avoid stepping on them. We were at least a mile from the post, seventy from Janet's house, 400 from my own. But crouching amid these emerald goblets, amazed by our surfeit of good fortune, we felt tranquilly at home.

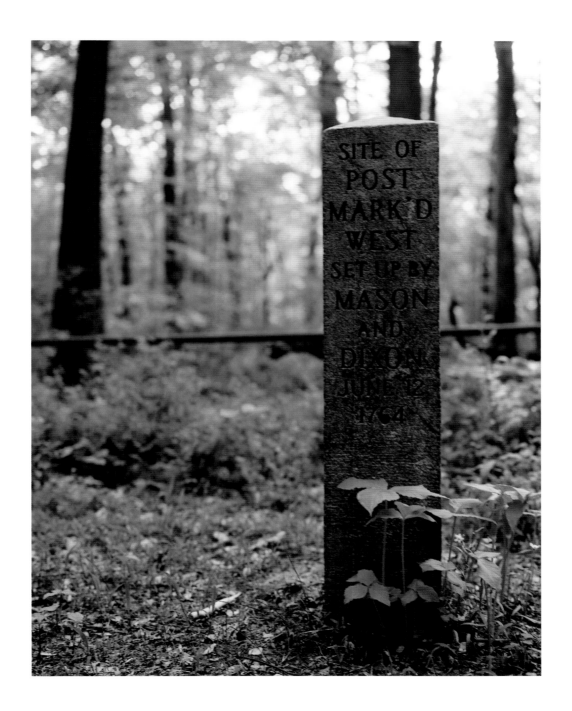

The last time I drove from Massachusetts to Pennsylvania, a commute I made regularly for a few years, I stopped in Connecticut. I'd been meaning to do so for a while, but it's a six-hour drive, at best, so I was loathe to add even a small detour. But on that Sunday I wasn't in a hurry (my commuting era was over), and I knew it might be a while before I made the trip again. I left I-84, followed unfamiliar "blue highways," those smaller roads I'd only taken when accidents made I-84 slow to a crawl, and ended up outside a middle school in **Redding, Connecticut**.

Across the street was the entrance to an inconspicuous nature preserve, where "Planet" had hidden a cache. I don't know Planet, but I'd chosen to look for this cache because I know of two photographers—Edward Steichen and Paul Caponigro—who used to live nearby and whose work I admire. I thought it'd be poetic to geocache and make a few photographs in their proverbial backyards. I love photographing where other photographers have been. Their pictures feel like a gift, a way of saying, *Here. Here's what I encountered. And here's what I made with the experience.* I can look at their photos beside my own, and literally glimpse something of the enormity of seeing and being.

That impulse is common among photographers, but certainly not unique to us. Many geocachers, too, value such visual sharing. Caches often include a camera, and many people post pictures to "galleries" on the geocaching Website. I think it's because sharing a place binds people to one another. When I walk where someone else has walked, we make more solid the bond between us. I hoped that, by walking where Steichen and Caponigro had, I'd come to know them better, maybe even feel their presence. I imagined I'd become acquainted with Planet, too. For with each step we leave a trace on a place. Sometimes our marks scar badly; other times, they seem nearly imperceptible, like a scent that only creatures of some other species, endowed with keener senses, are likely to take in. But always the trace remains, its reality no less for our disregard.

Many years ago, when Rob and I were in graduate school, we went to **Louisville, Kentucky**, each year for a literature conference. They were strange upstairs/downstairs days. We'd get a rent-a-wreck car to make the drive, share a hotel room with friends, eat heartily at the conference's free coffee and pastry bar each morning. But, after the talks ended each afternoon, we'd settle into deep, leather chairs in the sedately magnificent hotel bar at the Seelbach or the Brown, enjoy bourbon and branch and the generosity of two of our teachers. So I thought I knew where I was going when I headed to Louisville.

Someone called "Show me the Cache" has more than a dozen caches in this city on the Ohio River. Curious, I decided to search out his world, to live the city through his eyes. The ones I found were all microcaches, film canisters with strips of paper inside for geocachers to sign. At this cache, called "Peeping through the Fence," the canister was wedged tightly. Given time, I'd have been able to pry it loose, but the pedestrian traffic made me want to leave.

Almost everyone who walked by seemed to be looking for the drug dealer across the street. A few minutes earlier, when I'd driven slowly down the block, straining to read the compass on my GPS and watch the road at the same time, this man had approached my car. He'd walked up to the driver's side door as I blithely parked in what I'm now presuming was one of his "customer only" spaces. He just as smoothly switched direction when I lifted a camera off the passenger seat. As I began searching for the cache, he paced up and down the short block, hooking his head in a tense gesture toward men who hurried toward him from the alley or from around the corner. As man after man scuttled away, it became clear that I was hindering his commerce.

In retrospect, I realize it's probably foolish that I wasn't nervous. Mostly, I felt apologetic—sorry to be inadvertently interfering. Before I bid my quick retreat, I took a minute to peep through the fence, as the cache owner had urged, and to admire the yellowing leaves. And while I saw a side of Louisville I'd never seen before, I'm not at all sure I saw what "Show me the Cache" had invited me to find.

N 38° 15.181 W 085° 44.412

125

I spent much of last June rebuilding a stone wall at our place in Maine, heaving rocks into something that resembled a straight line, muttering bits of Robert Frost's "Mending Wall," as if his words would give me added skill. I enjoyed my amateurish efforts immensely—but felt conflicted, too. We don't need a wall. We have no farm animals, nor do our neighbors. So Frost's reminder that it's important to know "What I was walling in or walling out, / And to whom I was like to give offense" left me worried that I was, indeed, giving offense. Although I wasn't meaning for the low wall to keep folks out, I knew it would imply exclusion.

Geocaching has made me intensely aware how little land we share with one another— and of how important such sharing is. A month or so before I began working on the wall, I'd geocached on **Hilton Head Island, South Carolina**. I knew the area was reputed to be exclusive; still, I was surprised when a security officer for one of the island's private "residential plantations" refused us permission to drive down their street.

According to our GPS, the cache was not quite 500 yards straight ahead. But we had to make a wide, zigzagging circuit around the plantation to reach it. When we did, we read in a log entry that we were at the only public beach access point on the island. By then, the news did not surprise us: we'd seen so many "private" and "no trespassing" signs that we realized the island was scored by invisible walls, barriers not of stone but of privilege. Later, we learned there are actually four such right-of-ways to reach the beach—a number that seemed equally insufficient to me. I grew up enjoying the forty-plus miles of national seashore on Cape Cod, and now often kayak to islands off the coast of Maine, privately owned oases whose generous owners allow total strangers to put in. Such access to the ocean's edge seems to me a cultural "common good."

I know that some walls are indispensable. My question, though, is, How do we know which ones we need and which we might avoid—lest we wall out (or in) what we'll later wish we hadn't, lest we give offenses we'll later know to regret?

Before *Monopoly*™ there was *The Landlord's Game*, invented by a Quaker woman in 1904. Moving markers around a rectangular board composed of spaces with names such as "Easy Street" and "Lord Blueblood's Estate," players learned about the power of landlords and the struggles of tenants. Lizzie Magie created the game to promote Philadelphian Henry George's idea that having a single federal tax, one based on land ownership, would be both fairer and economically sounder than having a few landlords with a lot of land and many tenants with none. By the time Charles Darrow took his version of the game to Parker Brothers, the premise had been inverted: then, as now, players buy properties, fill them with dwellings, and collect rent from fellow players. Whoever has the most money when the game ends wins.

In **Dane County, Wisconsin**, one doesn't need dice and a thimble or top hat to get from Kentucky Avenue to Mediterranean and North Carolina avenues. A parking permit for Governor Nelson Park in Madison will get you close to them all. They are part of a grand suite, twenty-two caches all named after *Monopoly* locations, that "WISearchers" created to share some of their favorite places. For these caches, the WISearchers worked with a ranger to select nice areas of the park that people seldom visit. My sister, Gina, and I found all three on a sultry afternoon in June. Wandering around the park, we didn't encounter any greedy landlords—though we did have to fight off thirsty, insistent mosquitoes. Nor did we win or lose all we had: instead, we made pretty egalitarian trades, leaving a Euro coin and a carabiner, taking a packet of mosquito repellant and some bubbles.

Such anti-capitalist emendations to the old game may leave Charles Darrow reeling in his grave— but I'd bet my next roll of the dice that Lizzie Magie is whirling with glee.

When I was young, I couldn't understand why the Department of the Interior was called that. I knew that it was in charge of policies related to the outdoors. And I knew—or thought I knew—that governments don't have a sense of irony. So the name made no sense.

This virtual cache is located in a sad little park in the shadow of the ponderous gray headquarters of the Department of the Interior in **Washington, D.C.** To claim having found it, I had to answer questions about a statue there honoring someone named Rawlins. E-mailing my replies to the cache owner, I noticed that he lived in Rawlins, Wyoming—making his choice of statue suddenly clear.

General John A. Rawlins, a former Chief of Staff of the U.S. Army, helped survey for the Union Pacific Railroad in 1867. While the surveying party was in Carbon County, Wyoming, Rawlins tasted delicious spring water and reputedly declared, "If anything is ever named after me, I hope it will be a spring of water." The waters before him were immediately named in his honor, and the town of Rawlins grew up around them.

I thought it sweet that a general wanted to be commemorated by spring water, ironic that he ended up being lauded not only via the spring, but also by this statue and the city toward which it gazes. And though I know now that "Interior" really refers to inside the United States, I'm no longer sure irony is unusual in government matters: I am beginning to suspect, in fact, that it's quite common.

Irony thrives in urban settings, maybe because cities offer more jarring associations and pairings than do rural areas, more contradictions that can't be set to rest. But, as far as irony goes, all cities are not created equal; Washington, D.C., tops the American charts. While a sardonic cast tinges vision elsewhere, in D.C. it's the default condition. It's not just the incongruity of something like the statue of Rawlins presiding over algae-greened cement pools of undrinkable water that presents itself as patently ironic. It's that the whole city seems to shimmer with unresolved paradox: each fact and its counter are coupled, a Fata Morgana, as if in inadvertent proof of something the city seeks to hide and to reveal, both equally, both at once.

In June 2004, my sister and I headed to a virtual cache at Ronald Reagan's boyhood home in **Dixon, Illinois**. On the way, Gina spotted Lost Nation Road on our map and proposed we find it. We had plenty of time; we'd set out early, hoping to reach Reagan's home before any mourners arrived. We didn't want to interrupt their grief with a game. Sure enough, people soon came to pay their respects. We left to find coffee and Lost Nation Road.

In a bookstore-café downtown, we found coffee and a display of books on politics that revealed how deeply divided America has become, our national spectrum reduced to just two hues: red and blue. I half-listened as Gina told the owner about our road trip. When she mentioned that we'd started in Kansas, where she lives, he urged her to read Thomas Frank's *What's the Matter with Kansas?* It was sold out, so he summarized Frank's arguments about why Kansas, once politically progressive, had become a "red state."

Leaving Dixon, we located Lost Nation Road; nothing about the long straight stretch suggested how it had acquired its quixotic name. Driving along it, Gina and I began talking about what the bookstore owner had said, and about how different her neighbors reputedly are from mine. We ended up spending much of that day's drive comparing ideas espoused in Cambridge, Mass., with those endorsed in Kansas. The more we talked, the more our hearts sank, for the gaps between red and blue grew and grew. We searched for common ground, considered love, family, ice cream—all the usual verities. When I suggested geocaching, Gina chuckled. "Think about it," I mused aloud, "anyone can play—and anyone does." Red and blue, young and old, male and female, the devout and full of doubt all participate. "Do you think a game could be the great unifying force of the new millennium?" I asked. Gina eyed me sideways; I could tell she was trying to gauge whether I was being silly or ironic or sincere. Wisely, she merely nodded, and we rode in silence awhile.

But we could not shake the sense of having glimpsed something grim. Instead of the enigmatic cache we'd intended to visit, we'd espied a cleft at the country's heart, and understood better than we wanted to how nations become lost.

In **San Antonio, Texas**, the **Alamo** has become symbolic of the courage of a small band of Texian freedom fighters who challenged a far larger Mexican force at the mission-turned-military-post. A David vs. Goliath saga, pitting upstart freedom against oppressive authority, the story is full of sound and fury, beloved by many. In fact, the Alamo is the most popular tourist destination in Texas, annually visited by more than 2.5 million people.

Such places of pilgrimage are strangely fraught. They mean to be iconic, to condense history and shared meaning into stone and space. But as I looked around Alamo Plaza, watching visitors wander along separate paths, I felt hard-pressed to imagine we all share one understanding of where we are, of what we see. Still, people flock here, as to tourist spots in general, later telling friends "I was there; I saw that." We think (or hope) our friends will know just what we mean by "there," by "that." And places such as the Alamo reassure us that a common understanding might be within reach: this building and its history repeat themes adumbrated in the history lessons Americans learn in grade school. Visiting is less about discovering something new than about reminding ourselves who we think we are, and what we've been.

Pilgrimages aren't always like that. Wending one's way to Canterbury, trekking to Mecca, or reaching Angkor Wat—seekers make such trips because they sense the destination is somehow sacred, sublime, transcendent. Though we think we know what we will find, we also believe the place, and the experience, will be larger than we are, larger than we can imagine.

The pilgrimages that geocachers make are something else again. To create a cache is to invite strangers to share a place, to invoke the hope that others will see something of what you've seen, and say, "Yes, I understand; this place *is* special." But the specialness is not based in its being battle ground or holy ground; it resides neither in official history nor in the sacredness of all places. Geocache sites are consecrated by an entirely secular incantation, a childlike invitation to "come play here"—digitally recast, swollen with grown-up knowledge, as ripe with fear and courage as many poems are. Together, hiders and seekers forge a curious bond, one that transforms an estranged, estranging land into common ground.

A few years ago, on a beautiful summer day, I set out to get lost. I was wandering on an island near the Maine coast and noticed a faint gap, a space where the tree branches seemed not to overlap—a deer path. Though I'd been on this island many times before, I'd never headed in the direction that the deer apparently did. So I followed their slender trail, which led me to another and then another, until I'd left the main routes far behind. I was excited at the prospect of being in a relatively untrodden place. Partly, I was energized by feeling so far away from human constructions, even as I knew there was a house a mile away; partly, I was happy that my quixotic experiment seemed to be working, since I could not remember ever having been truly lost before. To be sure, setting out to get lost on an island is an exceptionally safe way to experience the disorientation and sense of discovery I hoped to induce. Even if I succeeded in losing myself, I knew I'd still be able to find a way back to my kayak—and probably well before sunset.

When I told friends about this experiment, some were surprised that I'd never been genuinely lost, others that I would seek to be. Part of my motivation was a nagging suspicion that timidity rather than a good sense of direction had kept me found, that maybe I'd never been lost because I'd never wandered very far off the beaten track—literally. And while I'll shoulder the responsibility for that tentativeness, it's not *entirely* my fault: it's getting harder and harder for folks in industrialized nations to get off the beaten track, even when they want to. There's so much track nowadays—from forest trails and bike paths, to gravel roads, rural streets, two-lane highways, and interstates—and so many signs directing us to everything from food, lodging, and gas to historic markers, scenic views, and natural wonders. Moreover, detailed maps are widely available that describe nearly every corner of this well-trammeled world.

Getting lost would be both easier and harder for me to do now than it was that day, because I've since acquired a GPS, a global positioning satellite receiver. More precisely, I have two—a handheld

unit and a navigational system in my car. These GPS receivers enable users to know, within a matter of feet, exactly where they are on the earth's surface. With a handheld GPS, one may not know exactly how to get from one's current location to a destination via roads or trails, but the GPS does reassure by giving a compass-direction route and a distance. Like trekking on an island, wandering around with a GPS provides the reassurance that one can't get very lost, a reassurance that lets many people (me among them) wander further than they might otherwise.

Until recently, ordinary citizens could not own accurate GPS receivers. A few luxury cars had moderately precise navigational systems, but only since May 2000 have accurate automobile systems and handheld receivers been available. Prior to that date, the United States government had a policy in place known as "Select Availability" (SA), which was an order to degrade satellite data, so that civilian GPS receivers would be far less accurate than military ones. Whereas the military devices were then accurate to within twenty feet, the civilian devices were accurate only to about 200 feet (in the years since, both civilian and military GPS receivers have become far more accurate). The intentional degradation was a preemptive defense measure, meant to ensure that the U.S. military always has more precise equipment than would the enemy. The Clinton Administration, however, maintained that allowing civilians to have access to improved GPS data would have commercial and social benefits, asserting that "worldwide transportation safety, scientific, and commercial interests could best be served by discontinuation of SA."[1] Many such uses have developed in the years since. I find it significant that the first recorded new use contributed neither to transportation safety nor to scientific interests; instead, it inaugurated the game that is the subject of this book.

As I noted in the Introduction, Dave Ulmer hid some items in a container in the Oregon woods and posted the latitude and longitude to an Internet newsgroup, in no small part to validate and celebrate the repeal of Select Availability. Within a week, two people found his hidden stash. One of them, Mike Teague, sensed that this could be a new outdoor sport, and he decided to create a Website where people could track objects they hid or found. From the start, the emphasis was on navigating in new and enjoyable public places, and on skillful hiding and seeking, rather than on exchanging valuable or exotic objects via the caches. The premises were simple: place a container with a logbook, and perhaps a few fun trinkets, on publicly accessible land; post the coordinates, thereby inviting others to come; if you find the cache, leave a note and, if you take a trinket, leave one in its stead; and, upon

returning home, let others know how you fared by posting a note to the Website. Soon after Teague found Ulmer's cache, he began to hide some himself. Just outside Seattle, Jeremy Irish found one of them. Excited by the potential he envisioned for the game, Irish proposed the name *geocaching*. By September 2000, Irish was maintaining the official geocaching Website, *www.geocaching.com*.

The game has grown rapidly. As of this writing, more than 200,000 active caches are hidden in 218 countries. With 400,000 currently registered users of the geocaching Website, Irish estimates that more than a million people play.[2] Indeed, in the last seven days alone, geocachers reported finding or hiding more than 135,000 caches on the main Website. I regularly see entries from players who have found thousands of caches, and others by people who have traveled the world in this pursuit. Geocaching has become a popular activity not only for individuals, but also for families, home schoolers, elementary and middle school classes, scout troops, and other social organizations. Recognizing that this activity provides a fun way to teach geography and math, for example, the geocaching Website includes a discussion forum on "GPS in education."

Geocaching involves intersections between people and the land, and, therefore, it highlights our ideas about places we deem beautiful (or otherwise worthy of sharing), about competing pressures on land use, and about new communities of people who "share" land but who do not necessarily live near one another. It incorporates playful methods for evading the constraining psychologies implicit to certain technologies—such as military satellites, surveillance cameras, and an extended information network—without having to leave mainstream culture. It involves navigation—walking and Web-wending, driving and dead-reckoning, efforts to figure out a healthful balance between old and new modes of transit, old and new methods of cartography. It creates opportunities for people to wander with both a feeling of security and a sense of uncertainty, anticipating they will find a treasure in an unfamiliar place. Geocaching gives contemporary people a means of being explorers that is not anachronistic, that is, instead, absolutely consistent with contemporary conditions. As a highly popular grassroots creation, geocaching is an evolving system that changes in response to internal and external pressures. New players bring new attitudes about what the game is and can be, and the rapid growth has prompted some non-players to want to prohibit or limit play. We cannot know what geocaching will become or how long it will last, but right now it is an extraordinarily popular game and a nexus for identifying connections among some significant cultural concerns.

THE LANDS WE LOVE

I was initially attracted to geocaching because it was a way to discover new and wonderful places to walk. I like walking and day-hiking, and geocachers, through both predisposition and the logic of the game itself, generously share favorite places. I wanted to know what these places are, what kinds of locales others find worthy of sharing. In addition to hiking in them for my own enjoyment, I wondered if these places might reveal important things about millennial Americans, a people who drive more than they walk and who spend most of their lives inside. I wondered if contemporary notions of natural beauty would be different than those described by writers and artists a century or more ago, people who had more wilderness and ruralness to explore. Would absence have made us hanker for the woods, or tremble at the sight of snakes?

For absent we are. According to the Environmental Protection Agency, Americans spend up to ninety percent of their time indoors.[3] Many scientists and social scientists believe that this tendency runs counter to our human nature. They argue that the human desire for engagement with the natural world is so pervasive and so intense that it is probably genetically encoded; thus, by being indoors so much of the time, we are denying ourselves something that we both want and need. We make up for that loss by filling our homes and workspaces with plants, by trying to supplement for the missing vitamin D our bodies need (and get via sunshine), by making offices with windows a sign of corporate success, and by eagerly throwing open said windows, when possible, at the first signs of spring.

In many ways a true cross-section of the population, geocachers also spend more time than is optimal indoors. But the fact that they play this game reveals that geocachers are doing something to fulfill their desire to be outdoors. I surmised that participants would hide caches in places that are particularly able to assuage their yearnings for time in nature, that they would choose places that allow them to make the most of their time outside. And similarly, I thought that, when people searched for caches, they would select the ones whose descriptions led them to believe the place would be compelling—and, thus, that the most popular caches would be at the most satisfying locations. Therefore, I began geocaching with the belief that cache locations would be something of a synecdoche for contemporary peoples' idealizations of the natural world. As a corollary, I expected people in different places would have disparate ideas about what counts as beautiful—that folks in

New England and those in Arizona would have different definitions of what constitutes a pleasing natural setting.

I was partly right and partly wrong. The majority of caches—and particularly the first ones placed in a given area—tend to be hidden in locations that are among the most pristine available. And those who find the caches do regularly commend players for having directed them to a beautiful spot, a forgotten oasis, a new place the individual thinks he or she would not otherwise discover. A survey done by Ingrid Schneider and Todd Powell of the University of Minnesota substantiates my anecdotal observations. Schneider and Powell surveyed geocachers from Minnesota about why they play, and offered respondents a list of twenty-six possible reasons, which they could rank from "very important" to "not important." An astonishing 98.5 percent said that "to enjoy the scenery of the woods" was a "very important" or an "important" reason that they play.[4]

This preference for locating geocaches in relatively undeveloped settings is entirely consistent with the observations that psychologist Peter H. Kahn, Jr. has made about the kinds of settings people enjoy, and about the characteristics we identify as beautiful in nature. Across cultures, Kahn argues, people have surprisingly similar tastes when it comes to natural beauty. In a wide-ranging study, he concluded, first of all, that people like "natural environments more than built environments." And while some preferences are influenced by where one lives, people everywhere demonstrate similar, basic predilections about natural environments. Kahn points out that we especially like "low action waterscapes" and landscapes that are "open, yet defined, with 'relatively smooth ground texture and trees that help define the depth of the scene'"—the kinds of places that get labeled as "park-like or woodlawn or savanna."[5] And we are most comfortable in places where we have the chance to discover new things but have a low likelihood of getting lost. Because these preferences seem universal, Kahn sides with those who believe that we have genetic encoding for some of our responses to nature. He surmises that we react positively to the kinds of environments where our ancestors would have survived most readily.

Geocachers demonstrate these preferences overtly. Although the majority of caches are located within 100 miles of an urban center, most are in places that seem relatively natural. I have visited far more places that include "low action waterscapes," for instance, than I have dramatic, high action ones—and far more places with water than I'd have anticipated. Oceans, rivers, lakes, ponds, pro-

tected wetlands, rice paddies that have been transformed into estuaries, waterfalls, even fountains in parks are favored attributes of geocache sites. Some of the sites I've visited are more like "medium action waterscapes"—100-plus-foot waterfalls or rocky ocean views. But with the exception of one cache on the Na Pali Coast on Kauai (see the frontispiece on p. ii), where thirty-foot waves buffeted the beach the day my husband and I visited, even the ocean-edge caches tend to be in places where the power of the ocean is partially quelled, as in harbors or coves. In places where water is not a dominant feature of the landscape, geocachers still tend to locate caches near it. For instance, while in the Texas Hill Country west of San Antonio, a place better known for its relative aridity than for its waterways, I visited five geocaches. Three were adjacent to water.

A tremendous number of caches I've visited were in the woods. At first, I attributed that proportion to the fact that I was geocaching primarily in New England, where both deciduous and evergreen trees are abundant, and where state parks and conservancies—while small—are plentiful. But in traveling to other parts of the country, I've found a similar preponderance of woodsy settings—with the exception of the Southwest, where such habitats are uncommon. In fact, this preference is nearly as persistent as that for water. For example, when geocaching in South Dakota, I found myself driving mile after mile over flat, open plains, and then—as I homed in on the cache location—spotting a grove of trees or a rocky, tree-shagged gulch. Similarly, when geocaching in a park in Illinois, my sister and I wandered for a long while through huge expanses of thigh-high grasses, but knew, as soon as we spotted a line of trees that had grown up along an old barbed-wire fence, that the cache was nigh.

And, in line with the third preference that Kahn observed, nearly all of the places I've geocached have been easy to navigate (and would have been easy even without a GPS). The game includes two measures of difficulty—one for how arduous the terrain will be, and one for how craftily the cache is hidden. Both speak to the expectation that easy navigation is the default; tougher navigation may be a source of pleasure for some players, and is an option, but those who might find it frustrating are able to avoid especially difficult excursions. Cache owners who place boxes in the woods often include coordinates for a trailhead as well as for the cache, implicitly promising a marked route. And, most of the time, such caches are within a few hundred feet of a trail. If one has to "bushwhack" much more than that, the difficulty level of the cache is raised to reflect the arduousness.

Some caches are in extraordinarily easy-to-navigate areas, such as urban parks. The preponderance surprised me at first. Because I expected geocache locations to be sites that could maximally assuage our longing to be outdoors, I also figured they would be in wilder places, outside the city limits. Many are, of course. But the edges of parks have become extremely popular cache locations—and, in some ways, the edges adumbrate the kind of settings I'd anticipated finding. Many urban parks are highly manicured knolls abutting less-tended areas that are still within the park's limits. In those adjoining acres, one frequently finds caches—as in Brooklyn Memorial Park, in Cleveland, Ohio. The main section of that park is beautifully tended, but the thicket-filled area between the park and a nearby parking lot is the location of the cache. Other caches are squarely within the park area—such as one in a small sculpture park in Cambridge, Massachusetts, or another in a tiny neighborhood park with a single slide and pair of bouncy toys in Halfway, Maryland.

As I found myself being directed to small parks across America, I tried to figure out why people would choose such settings; in addition to being less "natural" than the settings I'd expected would predominate (and indeed *do* predominate), these caches are also far more likely to be stolen or vandalized. It's hard to hide a cache in a park well enough that non-geocachers will not find it, but that geocachers will still be able to do so. Therefore, many non-players find caches. Some, of course, simply leave notes in the log indicating that they've found it, but others are less considerate, vandalizing or stealing the cache.

One reason that folks take the chance and put geocaches in parks, I think, is geographic ease. The overwhelming majority of people in the United States live in and near its urban centers; the 2000 Census indicated that 80.3 percent of the population lives on only twenty percent of the land.[6] Because cache owners must be able to check on their offerings from time to time, they need to hide them near enough to home that they can do so. Fortunately, some urban areas have significant open space within their city limits. In New York City, for example, one-quarter of the land is designated as open or park space, according to the Trust for Public Lands. And while an urban park may not seem like a congenial natural setting to someone raised in a sparsely inhabited region, it may well be deeply pleasing to someone raised in a densely built metropolitan area. It may feel wild, natural.

Kahn describes a phenomenon he calls "environmental generational amnesia" that has a corollary here. He notes that "people take the natural environment they encounter during childhood as the norm

against which to measure environmental degradation later in their life."[7] I suggest that not only what we regard as "environmentally degraded," but also what we consider "environmentally pristine" will be so shaped. Thus, while I may regard a golf course or a city park as a constructed setting, it may be bucolic to someone raised in a concrete jungle. This important perceptual difference came home to me quite forcefully when, at a flooded cement walkway in Anna Page Park, in Rockford, Illinois, my sister and I came upon three children in bathing suits who were playing, shrieking as they loudly dared each other to go into the water. They warned us to be careful because the water was cold and filled with crayfish. Taking off our hiking boots to cross this "dangerous" stretch, we discovered that it was about eight inches deep and marvelously cooling. Wildness is in the feet and eyes of the beholder.

Even in places where relatively pristine natural settings are few and far between, geocachers ferret them out. Geocaches are often placed at rest areas on highways; once, I visited one in the woods behind a weigh-station on I-95, the massive interstate that runs the length of the East Coast of the United States. In Washington, D.C., a geocache was hidden in a "Secret Garden" that truly was one, a tiny lush spot rendered nearly invisible by the surrounding crush of buildings. That geocachers call special attention to such places speaks even more insistently to the human desire to walk in nature, to find solace in natural settings, than do the caches that have been placed in less transformed, more obviously splendid environments, such as the Blue Ridge Mountains or the deserts of the American Southwest.

In addition to the caches which highlight a natural setting—whether in a large nature conservancy or in a tiny neighborhood park—others underscore something else that a cache owner finds noteworthy. Some are at historic sites or major tourist attractions, such as the Alamo (page 135) or Churchill Downs where the Kentucky Derby takes place (page 107). Some are at less famous attractions, such as the statue of Ronald Reagan at his boyhood home (page 132) or the gulch Jesse James jumped to escape the posse trailing him (page 67). Still others are at quirky tourist spots, such as one at a toilet seat museum in a gentleman's garage in Texas. Quite a few are at locations that pay tribute to early explorers and cartographers—such as the starting point of the Mason-Dixon Line (page 121) or the exact point where Minnesota, South Dakota, and Iowa touch (page 35). A further characteristic that distinguishes these more tourist-oriented caches from the ones in natural settings is that they tend not to emphasize walking, while the ones in natural settings nearly always include a hike, often of several miles, from wherever one parks.

DRIVE TO WALK

In Boston, which has a large and easy-to-use public transportation system, locally known as the "T," many geocachers create "T caches." They are not thematic, in the sense that they are not *about* the train system; they are simply linked by being accessible via public transportation. Such caches serve two groups especially well: visitors to a city that attracts many tourists, and local geocachers who do not drive (or do not want to drive in this notoriously difficult-to-drive place). Such caches, like the historic caches I just mentioned, contrast sharply with the caches that encourage a walk in the woods—but that also require a car to reach them.

A reliance on cars has become part of the fabric of life in the United States. In fact, writer Rebecca Solnit asserts that walking has become nearly a lost practice in the United States, and that 1970 marked the end of the golden age of walking, for in that year "Americans were—for the first time in the history of any nation—suburban."[8] The design of suburban neighborhoods, sprawling with plenty of room for automobiles but often without sidewalks, is not conducive to walking. When I lived in eastern Pennsylvania, I often drove twelve miles to Valley Forge National Park to walk a few miles, then got back in my car and drove home. Only recently did it occur to me that this act of driving a long way to walk a short one is peculiar. I hadn't thought it through, in part because it is so common (akin to driving to the gym to use a treadmill or elliptical bicycle rather than walking outdoors or using a conventional bike), and in part because it was a question of safety. My neighborhood lacked sidewalks.

But that very circularity—driving in order to walk at a safe distance from traffic—makes me mindful of the pervasive ways in which cars have transformed American daily life. First and foremost, as Solnit points out, automobiles are fundamental to suburbanization. The twentieth century was marked both by this suburbanization of America and by an extraordinary increase in the number of cars Americans owned and the amount of time spent in them. In 1990, the ratio of people to cars in the United States was two-to-one. Moreover, we don't just have these cars, parked in driveways. We use them. A lot. In 2001, Phillip J. Longman, a Senior Fellow at the New America Foundation, noted that, "on a typical day, the average married mother with school-age children spends 66 minutes driving—taking more than five trips and covering 29 miles," more time than is spent on feeding, bathing, and dressing the children. Further, Longman observed that, "while the U.S. population has grown nearly 20 percent, the time Americans spend in traffic has jumped . . . 236 percent" and that "the average driver

now spends the equivalent of nearly a full workweek per year stuck in traffic."[9] This rise in commuting time is not an incursion into work time, which has not diminished. Instead, the seventy-two minutes per day that the average American adult spends driving must be taken away from leisure time.

While people can—in principle—change jobs or residences to avoid onerous commutes, doing so is difficult. The 2004 Urban Mobility Study suggests such moves have not occurred; to the contrary, the study notes that "congestion has spread to more cities and to more of the road system and trips in cities and more time during the day and to more days of the week in some locations."[10] One sign of change, however, is increased interest in efforts, such as New Urbanism, to create communities built around pedestrian traffic rather than car traffic. In fact, in referendums during the year 2000, voters across the nation approved 400 of 553 ballot measures related to "smart growth," many of which were efforts to encourage pedestrian-friendly communities, to mandate a mix of housing types, and to promote reduced dependence on cars.[11] These measures signal a growing dissatisfaction with the pace and style of contemporary American life, but they will take a long time to implement in a significant way. Until such a time, many suburbanites continue to turn to local palliatives, to a host of specialized services designed to help people fit necessary tasks into days that are effectively shorter due to these long commutes. Not surprisingly, many of those services require that folks get back in their cars and drive to one of the local strip malls to do errands. While such spots provide efficiency by clustering businesses, they do so at the price of replacing the old-fashioned town center, thereby creating a lacuna that New Urbanists, among others, bemoan.

Partly for convenience and partly for lack of time, many people also turn to their computers to do their errands: communicating with friends via e-mail rather than posted letter, shopping on-line, completing bank transactions and paying bills electronically. In a culture in which we feel very hurried, in which we fear we don't have enough time to get everything done, it is no surprise that walking as a form of productive locomotion is in decline. It *does* take longer to walk to the grocery store each day than it does to drive to the superstore once a week. It *does* take longer to walk to a bookstore than to click a few buttons and get books delivered to one's door from an on-line bookstore. Solnit observes that we have become so reliant on machinery that enhances our speed that the "unaugmented body," by which she means a body not coupled to a car or other accoutrements that make it able to go faster, is now "rare." Because we use our bodies in their unaugmented form so much less frequently, she argues, the body itself has "begun to atrophy as both a muscular and a sensory organism."[12]

As the muscles atrophy, bodies overall are getting larger and larger. In the United States, unprecedented numbers of children and adults are now clinically obese. In fact, obesity is such a concern that, in July 2004, Health and Human Services (HHS) Secretary Tommy Thompson announced that language about obesity in the Medicare guidelines would be changed so that treatment could (in some cases) be covered. Because obesity is most often caused by highly caloric diets and insufficient exercise, calling it an illness is a vexed issue. However, it contributes to many illnesses, and the HHS wants to address those issues. In addition to examining our food supplies or exercise habits, an environmental factor worth addressing is the continued proliferation of suburbs and urban sprawl. A study released by Smart Growth America in 2003 revealed a clear link between weight and urban sprawl. It reported that "people who live in more sprawling counties were likely to be heavier than people who live in more compact counties."[13] And the differences can be considerable. The study noted that, after controlling for variables such as age, gender, and diet, someone from the most sprawling county weighed *6.3 pounds more* than her or his counterpart in the most compact community. The single biggest factor to which this difference seemed to correlate was frequency of walking, both as a form of leisure activity and as a means of transportation: "people in the 25 most sprawling counties walked an average of 191 minutes per month, compared to 254 minutes per month among those who live in the 25 most compact counties."[14] That is to say, the folks in the most compact counties walk about an hour per month more—and are thinner for it.

Much like Barbara McCann and Reid Ewing, the authors of the above-mentioned report, Solnit acknowledges that this decline in walking has happened in no small part because contemporary bodies have come to seem insufficient for meeting the demands we've created: an unaugmented body can't keep up in our fast-paced world. Children need to take the bus to school because it is too far to walk, and they require transportation to their many extracurricular activities. Adults need some form of transportation to get to the workplace because it, too, is usually too far away to reach by walking, and we have too many errands to squeeze into a day to manage them all on foot. In short, sprawl makes walking not only dangerous, but also impractical.

Solnit is hardly alone in identifying the reduction in walking as a loss and in urging people to incorporate walking into their lives. Medical doctors and research scientists point out that walking would not only help us to address obesity, but also enhance overall physical health, cognitive abilities, and memory. Artists who have cultivated walking as part of their work, such as Richard Long and

Vito Acconci, make clear that walking permits a profound engagement with the physical world, one that can be transformative. Recognizing these benefits, Solnit expresses hope that people will re-embrace the unaugmented body, seeing it as valuable in itself and as a symbol. She suggests that an unaugmented body might be a revolutionary tool and that walking might be a kind of social and political subversion, suggesting that "it may be counter-cultures and subcultures that will continue to walk in resistance to the post-industrial, postmodern loss of space, time, and embodiment."[15]

N. Katherine Hayles is also quick to point out that we rarely use our unaugmented bodies anymore. But her emphasis is quite different; she maintains that we have become cyborgs. Though thinking of oneself as a cyborg might seem fantastical at first, recognizing our reliance not only on automobiles and other modes of transportation, but more importantly on various cybernetic technologies—computers, communications devices, and medical technologies that enhance our capabilities—makes the idea less distant than we might have initially supposed. Hayles asserts, further, that contemporary humans are so thoroughly intertwined with these technologies that we are on our way to becoming a distinctive species—"posthumans." I believe geocaching is an example of a posthuman mode of play.

Like the artists and countercultural figures Solnit describes, geocachers form a new and significant walking subculture. But their walk is crucially different from the way humans have walked for centuries. The importance of that distinction is reflected in the difference in popularity between geocaching and its nearest kin—*letterboxing*. Invented in 1854 in Great Britain, letterboxing began when a gentleman placed his calling card in a bottle and left it in a secluded spot in the Dartmoor region, inviting others to do the same. Dartmoor is now estimated to have between 10,000 and 40,000 letterboxes. In the United States, the sport began to garner interest when *Smithsonian Magazine* published an article about it in 1998.[16] Like geocaching, letterboxing involves walking to a site, using navigational clues to find the location, and leaving a message to indicate one has been there. But letterboxing enjoys a far more modest popularity in the United States than does geocaching, with about ten percent as many letterboxes hidden as geocaches.

The chief difference between the two activities is that letterboxers can play using an unaugmented body, like that of a Victorian-era gentleman, but geocachers cannot. To the contrary, the bodies that wander through the woods or deserts of the geocaching universe are profoundly enhanced,

jacked into two of the largest virtual data networks available—the Internet and the GPS satellite system. Players *must* use virtual technologies to augment their corporeal selves, very often doing so in order that those corporeal selves might temporarily escape the built world. They use the very tools that have contributed to the declining health of both people and the environment to participate in a more corporeally engaged, environmentally attuned life. This paradoxical situation alerts us to the fact that geocaching might give us insight into the current transition from human to posthuman.

HUMANS 1.1

Although people are doing less walking nowadays, the ability to walk is a very important characteristic of human beings. Two-legged walking is one of the key changes that paleoanthropologists identify in the evolution of early hominids into the groups that eventually led to contemporary humans. Consequently, these researchers pay special attention to the specifics of how walking evolved and how other species walk. As the importance of the new form of walking implicit to geocaching became clearer to me, as I understood the absolute necessity of being "augmented" in order to play, I also began to realize that it wasn't so much the irony of using military satellites to hunt for silly putty that had pricked me (though I do like that). It was the implications of *having* to incorporate virtual technologies into one of the most basic human activities. By employing this new way of walking, geocaching reveals a change between what humans have been and what we are becoming.

Hayles is not alone in making claims about the emergence of posthumans. In the last few years, articles and books on this topic have become relatively common. Along with Hayles's *How We Became Posthuman*, Francis Fukuyama's *Our Posthuman Future* is perhaps the best-known; both of these books stress the twinned contributions that biotechnology and information technology are making.[17] Hayles's descriptions resonate particularly aptly with aspects of geocaching. In fact, two of the four key features of her "posthuman view" directly connect to this notion of the augmented body. She argues that the idea of the body as inviolate is replaced in the posthuman view; from this new vantage, she says that we think of "the body as the original prosthesis we all learn to manipulate, so that extending or replacing the body with other prostheses becomes a continuation of a process that began before we were born." This sense of permeability of body boundaries means not only that one might add cochlear implants, for instance, but also that one can be interconnected with machines.

In this view, moreover, the "human being . . . can be seamlessly articulated with intelligent machines. In the posthuman, there are no essential differences or absolute demarcations between bodily existence and computer simulation."[18]

In using a GPS receiver and the Internet, geocachers are bound to the communications devices that provide them with data and with access to one another. Tellingly, Marshall McLuhan described this kind of media-immersion more than forty years ago, employing terms that are close to those that Hayles now uses. He calls this sort of device a "remote prosthesis," for rather than incorporating the prosthesis into our bodies, we extend our bodies by linking into the prosthesis. We "put our central nervous systems outside us in electric technology."[19]

Such descriptions tend to engender terror or excitement, calling to mind fictions ranging from William Gibson's *Neuromancer* to Richard Powers's *Galatea 2.2,* to a host of science fiction novels, television shows, and movies. Among the most familiar fictional accounts is surely *The Matrix*, which presented a wide range of body-machine fusions. In such works, the prostheses are not merely supplements that allow injured characters to "return to normal"; instead, they let the characters go beyond the capacities of an unaugmented human. And audiences are encouraged to yearn either for the good old days of corporeality or for the promise of freedom from the body that machines might offer. Such fictions depend, for their impact, on our interest in, and anxiety about, becoming posthuman.

Our responses to real humans becoming posthuman are often far more blasé. As a child, I found the "six million dollar man" and "bionic woman" so captivating that I still recall the soundtracks that accompanied their superhuman feats. But when my father got a titanium hip a few years ago, my sense of how incredible that prosthesis was wore off even before he had finished physical therapy. In part, it's because he can't leap onto rooftops. Still, the new hip allows him not only to do more than he'd been able to do for years, but also to have greater agility than he would have had with a healthy hip of his own. The likeliest reason for my sanguine attitude—for our sanguine attitudes—is that the changes we witness are so much more modest than the ones recounted in movies and literature that few of us sense their significance.

But every once in a while, we are able to appreciate a change as it is happening. Because I've been teaching college for a long time, I've witnessed the ways in which late adolescents—who are routinely heralded as the "early adopters" of new technologies—have adapted to the growing possi-

bilities offered by computers. And I recall the first time I realized these students had begun to shift adeptly between physical and virtual worlds. In the early 1990s, freshman composition students often complained that working on papers in a computer lab (those nearly obsolete rooms on college campuses that housed thirty computer stations linked into a mainframe) was impossibly distracting. In the mid-1990s, some students invited me to a group graduation party in the common room of their dorm. In one corner of the room a computer was linked to the Internet, and one of the hosts sat at this computer for much of the evening. He would chat with folks a while, then surf the Internet, then chat. I found this decidedly un-partylike (and impolite). But what matters more is that his peers did not. Just a few years after they had complained about writing in a computer lab, these students had become so adroit at splitting their attention between the two realms that doing so was utterly normal. That seamlessness, and the changes in their social codes that acknowledged it, revealed that a thorough-going integration of computer technologies had become a new norm. Over the last decade, such a splitting of attention between cyberspace and physical space has become common for people of many nations and generations.

The capacity to integrate the physical and virtual worlds in a healthy way is one of the compelling things about geocaching. The game creates opportunities for participants to *extend* their capabilities without *undermining* the fact that humans are embodied creatures in a physical world. Players do not replace actual walking and actual searching for the cache with a joy-sticked computer simulation, but they must use a computer to participate in the game. Hayles has noted that one of the most serious implications of the posthuman view is "a systematic devaluation of materiality and embodiment"; she recognizes that, as we spend more and more time in the virtual world, we may take less care of, and have less interest in, the physical.[20] Similarly, Hal Foster has suggested that one of the most problematic "dis/connections" of our current postmodern world is that "our media world [is both] one of a cyberspace that renders bodies immaterial" and also one "in which bodies, not transcended at all, are marked, often violently, according to racial, sexual, and social differences."[21] These equivalently dangerous relationships are both widely evident right now—exemplified by the lack of true care many people give to their bodies or to the physical world, as well as by hostilities perpetrated against people whose bodies (in terms of ethnicity, sexuality, or other attributes) differ from one's own.

Geocaching suggests an alternative trajectory, a way to use cyberspace without becoming disembodied, and a way to keep the body without having it defined in essentialized ways that put one at risk. Geocaching demonstrates that individuals who are both technologically sophisticated and environmentally engaged can and do use an extended communications network and a highly developed navigational system *not to supplant* a formerly physical engagement, *but rather explicitly to promote* such an engagement—extending our capabilities and adapting to permit new activities and to promote new forms of community.

As humans, part of what we do is adapt. A defining characteristic of *Homo sapiens sapiens* is an extraordinary mental flexibility and adaptability that enables us to interact dynamically with our world. Though our species name is usually translated as simply "modern man," it is more apt to say we are "humans thinking about thinking." Because we can reflect, we are well-equipped in most environments (physical, cultural, and political) to invent, adapt, and participate consciously in our own evolution. And in looking back at some of the huge transformations in the relationship between humans and their environments—the beginnings of agriculture, the inventions of the wheel and of writing, the development of clocks, electricity, and the computer—we see major changes that have forever altered how we live. We do not say, though, that those changes propelled us from being one species into being another. But if Hayles and others are correct in saying we are becoming posthuman, then they are implying that the transformation they identify is of a different order. Through becoming so interconnected with technological devices, we are reshaping not only our daily lives, but also humanity itself.

As humans and machines become more (and more profoundly) inter-articulated, artists, cultural theorists, scientists, and technologists in academic and industrial research facilities are exploring the limits and implications of such change. In a set of research projects currently underway at the Massachusetts Institute of Technology, for example, participants are asked to live for a month in a highly technologically-mediated living space and permit themselves to be monitored continuously so researchers can evaluate how they interact with new technologies. Like the "Microsoft Home of the Future" with its smart door and smart appliances, or the new Lexus which can remotely recognize its owner, the research that MIT is conducting is intended to create smart objects that are conjoined to their users in ways that consumers value. In light of such developments, the seeming boldness of the claim that we are becoming posthuman seems further attenuated.

As important as attributes such as two-legged walking are to being human, perhaps the most critical characteristic that distinguishes humans from other species is our self-consciousness. Our engagement with machines changes that attribute as well; we are literally, as well as metaphorically, altering how our minds engage the world. When our ancestors learned how to make tools for hunting and how to use fire to cook, they were able to spend a little less time getting food while also enjoying improved nutrition. Those alterations in diet are thought to have been key in leading to the larger brains that are a distinguishing feature of our species. Like our ancestors, we are developing new tools that have led, in a very real sense, to the formation of a much larger brain. This new big brain—the immense distributed network of people and computers that extends over the entire planet and into our satellite systems, this externalized "nervous system" to which McLuhan refers—is allowing us to do new things and is contributing to rapid transformations in how we use the bodies and brains we currently have. We have access both to information and to experts via the Internet that would have been prohibitively difficult or time-consuming to find, or impossibly expensive to use, just a decade ago. Moreover, because memory is such a crucial part of consciousness, our capacity to store so much data remotely both extends the size of our memories and reduces the sense of urgency that we store certain information in our actual, corporeal heads. *Homo sapiens sapiens* often functions now as *Homo sapiens virtualis*—man thinking with, about, and through virtualizing technologies. And, like our predecessors, we use our larger brains to accomplish tasks more rapidly; but the corollary, in our case, has been hastening the pace (and stress) of daily life.

MORE THAN A GAME

We externalize our memories and cultural concerns into many kinds of distal storage devices, not just into computers. Games are a particularly significant technology for storing such material. In *Understanding Media*, Marshall McLuhan pointed out that "games are popular art, collective, social *reactions* to the main drive or action of any culture."[22] They are sites where we can express social or cultural tensions and can engage those tensions safely. In fact, their ability to support such explorations makes them psychologically useful. "Play," McLuhan continued, "goes with an awareness of huge disproportion between the ostensible situation and the real stakes. . . . the game, like any art form, is a mere tangible model of another situation that is less accessible."[23]

With geocaching, many contemporary cultural tensions are in play. Rather than being overt in the content of the game, such tensions are implicit in the tools and rules, and in the way those rules are engaged by the players. One of the main issues, the one I've been addressing so far, is how players find a balance between physical and virtual existences, living both in the woods and on the web, maintaining a body-based connection to the natural world while also participating in the informational and social world the Internet and other virtual technologies permit. Geocaching doesn't give the answer; it simply gives people one opportunity to engage safely and obliquely a tension central to life, particularly life in America in the new millennium.

The game also lets us explore how community might work in a future in which living in close proximity to one another is neither a precondition for nor a guarantee of a successful community. As McLuhan noted, games provide "tangible models" for situations and concerns that are too large or complex for us to grasp fully. Geocaching provides participants with a very small set of rules about land and interaction. The requirements to use public land, to inflict as little harm as possible to an environment (no digging, no cutting of live foliage), to abide by federal prohibitions, and to care for any caches that one places imply some aspects of the relationship to the land that are likely to emerge. But they do not define them. Similarly, the expectations that one will provide accurate information about a cache location, fill the cache with materials that will neither offend nor harm, and record visits all imply certain notions of collaboration and gift-giving that can be fundamental to creating and maintaining community. But they do not guarantee that such a community will evolve.

Before I consider the ways in which participants in this game enact models for interacting with the land and with other people, I wish to note two ways in which geocaching revises some of our expectations for games themselves. These changes—like the recognition that geocachers must walk with augmented bodies—reveal subtle, but suggestive, differences from what has come before. They show us that even our ideas about the compartmentalization of play are breaking down.

Almost fifty years ago, Roger Caillois published an extremely influential work on games entitled *Man, Play, and Games*. There, he outlined six characteristics that games evince: *games are free*—in the sense that one is not obligated to play; *games are separate*—they are "circumscribed within limits of space and time, defined and fixed in advance"; *games are uncertain*—the result is not fixed in

advance and there is latitude for innovation by the players; *games are unproductive*—they create "neither goods, nor wealth, nor new elements of any kind; and, except for the exchange of property among the players, [they end] in a situation identical to that prevailing at the beginning of the game"; *games are governed by rules*—the laws of the game supercede ordinary laws; and *games are make-believe*—they are "accompanied by a special awareness of a second reality."[24]

Geocaching is consistent with most of these traits: it is freely undertaken, uncertain, rule-governed, and enhanced by a sense of make-believe. And while largely unproductive in the sense that Caillois means, geocaching is not fully so. In this book, I've emphasized looking for geocaches, but the flip-side to that is that another geocacher placed those boxes in the woods for others to find. And some geocachers are far more interested in hiding than in seeking. Each day, new caches are created, thereby extending the game space, and often adding variations to the basic game design. Because the game grows with each cache placed—both in its internal scope and its impact on the non-geocaching world—conditions do not return to those that existed at the outset of play. Further, the evolution of the game has led to some productive consequences—most notably "Cache In Trash Out" events. Often held in April, during the week of Earth Day, geocachers designate locales that are in need of clean-up as meeting places. The participants socialize while removing trash from a park or a stretch of woodland or the area around a lake, so that the area will be safer and cleaner. What is produced is not an exchangeable good, but a common good, a locale that will be more enjoyable for everyone. As geocaching has evolved, a more general ethic of "cache in, trash out" has become so ingrained that the acronym CITO routinely appears in Weblogs. People will note that a cache area "could use some CITO help," for example, meaning that visitors should bring a bag and clean up while they are there.

An even more palpable difference between geocaching and the games Caillois defined has to do with the game space. He stressed the separateness of the game, both in space and in time, from ordinary activities. Such a domain can usually be thought of as an overlay onto the existing physical world: a football field is really the grass and white boundary and hash marks on a flat expanse of dirt. And while the game is taking place in that game space, said Caillois, it cannot be used for another purpose (I can't fly a kite or play frisbee on the football field during a game). In that regard, Caillois said, the game space is "pure" for the duration of play.

In geocaching, the relationship between game space and preexisting physical space is significantly different. Geocaches are primarily located on public lands, which by their very nature are heterogeneous and multi-used. The game space of geocaching is, therefore, not pure, not even for the duration of play; instead, the game space is an invisible overlay onto a preexisting place, a largely intangible transformation of it. Consequently, the place continues to be other things to other people even as it functions as a game space for geocachers. The Alamo (page 135) may have been a virtual cache to me when I visited it, but it was still The Alamo. And it was a historic site, a place of work, a convenient meeting point, and likely many other things to the other people who were there that day. Because the presence of a geocache does not preclude others from being in a place and engaging it in other ways, it might be most accurate to say that not only is the game space of geocaching *not* pure, but also that caches alert us to the inevitable impurity of spaces.

One important consequence of apprehending this virtual overlay onto geography is that it reveals our changed understanding of spaces themselves. Like the teenagers who can carry on conversations with friends simultaneously through text-messaging and in person, this overlay highlights that we have grown accustomed to a technologically mediated layering of social experiences in a single environment. The fact of doing so is not new, but the degree to which we do so is.

In defining the criterion of separateness, Caillois stressed that a game is constrained not only in space, but also in time. It has a finite starting and stopping point. Geocaching deviates from this characteristic as well; so long as a cache is at a location, one can seek it. And while some parks have rules that limit caches to a year, most do not. Further, because there are no rules about how many caches one can seek, or how long a time one may participate in this endeavor, or what time of day or night one can search for a cache, no temporal boundary is created. Some caches may be unavailable at night, or during certain seasons, but these are local limits, rather than general ones. Moreover, because it is a worldwide phenomenon, and one in which players act discretely rather than in concert, one does not even need to arrange a time to play with other participants. Thus, quite literally, at any given moment, someone, somewhere, is likely hiding or seeking a cache.

NO MORE PLAYING IN PUBLIC

With this increased popularity has come a host of new interests in, and concerns about, geocaching.

Many regional and state parks have warmly welcomed geocachers—some sponsoring their own events, others permitting multiple caches in the parks. Some parks have had more modulated responses. The Cleveland Metroparks has been at the forefront in developing policies that balance concern over the environment with an awareness that this new activity is a valid and valuable way for the public to enjoy the parks. Its way of balancing between conservation and access has been to establish many park-sponsored caches and to permit individual geocachers to place their own for up to one year in an approved location. After a year, the cache must be retired or moved to a different location, a policy meant to balance this new activity against concerns about added wear and tear to the environment.[25] But some parks officials have strongly resisted the game. Many park superintendents at national parks expressed reluctance to allow geocaching on the lands they manage. In response, the National Park Service (NPS) officially prohibited geocaching in all NPS-managed lands in October 2002.

I was disappointed that the NPS prohibited the game. That ban means that public lands which have often been preserved for their beauty are unavailable for playing a game that, in large part, celebrates walking in beautiful outdoor settings. Moreover, I fear the ruling signals to regional and local wilderness management groups that it may be appropriate to ban geocaching, and such bans would further reduce the locations available for gaming. Indeed, the U.S. Fish & Wildlife Service, which is responsible for oversight of national wildlife refuges, did follow the NPS lead, as have many park services responsible for smaller parcels of land. If players cannot use national parks, which have been conserved and held in trust for all citizens and which the NPS itself considers to belong to all Americans, then players are deprived of both some of the most likely and the most lovely venues. Of the 286 million acres of "special use" lands in the United States (the designation for parks, wilderness areas and the like), 96 million are national wildlife refuges while another 84.4 million are managed by the NPS.[26] Thus, while one cannot say precisely how the prohibition will alter site selection criteria for players, it is inevitable that removing more than sixty-three percent of the most congenial land from consideration is having an impact.

I wish to consider the policy itself in some detail—for just as examining the game alerts us to ways that cultural concerns are manifest, attending to the opposition it has engendered provides a useful vantage on contemporary culture. In banning geocaching, park officials are implicitly saying

that the risks associated with the game outweigh the benefits. Evaluating such benefits and risks is at the heart of the very difficult—and historically contradictory—mandate of the NPS: on the one hand, its job is "to provide for the highest quality of use and enjoyment of the National Park System by increased millions of visitors in the years to come" while, on the other hand, working to "conserve and manage for their highest purpose the natural, historical, and recreational resources of the National Park System." In light of that mandate, the longstanding ban on geocaching at historic sites managed by the NPS seems entirely appropriate: the "highest purpose" of those sites is their archeological and artifactual character, and so a ban on recreational activities is consistent with overall NPS policy. But most of the parks are intended as natural oases in which recreational activities can be undertaken, and generally acceptable activities for those sites include "boating, camping, bicycling, fishing, hiking, horseback riding and packing, outdoor sports, picnicking, scuba diving, cross-country skiing, caving, mountain and rock climbing, and swimming."[27] Other, environmentally harmful activities, such as snowmobiling and licensed hunting, are even allowed in some of the nation's most glorious parks. Given that so many of the activities on this list pose far higher conservation threats than does geocaching, the ban at recreational parks seems counterintuitive.

Furthermore, the ban is inconsistent with the policy of the Bureau of Land Management (BLM), which is the agency within the Department of the Interior responsible for managing the largest acreage—264 million acres in 2003. The BLM finds geocaching an appropriate "casual use" of the lands, though it notes that there are some environments—at "Congressionally designated wilderness or wilderness study areas, at cultural resource sites, at areas with threatened or endangered species"— where it might be less appropriate. Even in those areas, the game is not absolutely prohibited; instead, the memorandum describing the geocaching policies says that "it would be appropriate to issue a letter of authorization with special stipulations attached that would address those concerns."[28]

Puzzled by the contradictory reactions of the BLM and NPS, I contacted the program analyst who authored the NPS ban, Marcia Keener, to ask her about the October 2002 statement which expressed uncertainty about the future of geocaching in NPS managed areas, and led to its eventual banning. The rationales for banning it proffered in that policy statement were: "there is often an anonymous nature about [geocaching]," and "employees of the National Park Service are naturally concerned that our policies and objectives are being deliberately ignored and bypassed—without suitable

recourse to responsible parties to correct any problem that might occur."[29] The crux of the ban, as articulated, is that the anonymity of participants makes it impossible for the NPS to assign culpability if the presence of a cache creates a problem. The NPS is largely correct about this difficulty. The rationale, however, seems uncompelling when one recalls that most persons who visit the parks do so without registering, and hence are anonymous. NPS officials would have difficulty assigning culpability for most transgressions perpetrated on these public lands. Moreover, NPS officials do have a means of finding out—to a limited degree—who placed the cache. All geocachers who use the main Website are required to provide a valid e-mail address. Thus, while an official who wished to contact the cache owner would not necessarily be able to find out her or his real name, that official could find out the person's e-mail address from Groundspeak, the company that runs the Website, and could initiate contact.

Recognizing that the anonymity of players does not differentiate them from other visitors, I asked Keener about the other point—the notion that parks officials are "naturally concerned" that players would misbehave, and that they are worried about not having the ability to "assign culpability."[30] The concerns with anonymity, threat, and blame seemed of a piece with many new policies adopted or bolstered as part of "Homeland Security," and I wondered if heightened security fears in the aftermath of September 11, 2001 prompted the shift in policy. Keener assured me that the policy was not created in response to such fears, that at the heart of the prohibition are more longstanding and prosaic considerations. For example, some geocachers who created caches in 2000 and 2001 did not ask for permission to hide caches in these public park lands—whether because it didn't occur to them that they might need permission or because they felt they shouldn't need permission. And some rangers, then and now, regard geocaching as an inappropriate use of the lands they manage. While the precise reasons that these rangers object to geocaching vary, many emphasize the risk of people parking in non-designated areas and of people hiking off-trail. Some fear that geocaches might contain dangerous or untoward items. Responsive to the concerns of the rangers and superintendents who manage the lands, the NPS banned the game. That reaction made many geocachers feel beleaguered, and they complained loudly, sometimes to parks personnel, more often to one another on geocaching discussion forums. Their tone and expressions of indignation reinforced the NPS staff's sense of geocachers as often unruly and anarchical, and thus the impression that a ban is appropriate.

In the summer of 2004, responding to the public's growing interest in geocaching, Keener and other NPS officials began to review the ban, soliciting information from a variety of sources to determine whether repealing it might be appropriate. If that repeal occurs, then individual park superintendents would have authority over whether and where caches can be placed in the lands they manage. Some geocachers will no doubt remain disappointed, since the park superintendents in a given area may continue to impose a ban locally and since the NPS is likely to permit only "virtual caches," the sort that require solving riddles to find a location rather than finding a container. But repealing the federal ban would nevertheless be a significant improvement, an essential first step. Keener's willingness to address the conflicts between the desires of geocaching visitors and the resistance of various parks officials may signal an important shift in the official position of the NPS. As a geocacher and a citizen who values an open democracy, I am appreciative of her hard work, optimistic that collaboration might occur.

These efforts are proceeding, albeit slowly; park superintendents are being educated about geocaching. Keener is working with NPS staff and members of the geocaching community to develop prototypes of virtual caches that meet both the goals of the NPS and the interests of geocachers, as well as to develop a permit system like that used in many state and local parks, so that superintendents can be involved in selecting safe locations for virtual caches.

As heartened as these possibilities make me, I recognize that they do not negate the underlying significance of the ban. Indeed, contemplating this prohibition continues to be relevant, because it signals much about official attitudes not only toward the game, but also—and far more crucially— toward the public's rights of access to the public's lands. In preemptively curtailing reasonable use of lands that are held in public trust, the NPS ban is more dangerous than helpful. At a time when access is being limited to many parks because of underfunding and budgetary cuts, the ban further erodes our sense of shared ownership of a common, and highly prized, natural resource. Further, in being based on *a priori* mistrust and the presumption that players intend to disobey the rules, the ban reinforces the culture of fear that is transforming Americans' relationships to people and to the world more generally. Because access to mutually beneficial "common goods" has been critical to defining and maintaining democracies, a policy such as this risks undermining the democratic principles America seeks to protect and advance. Policy-makers and enforcers, it seems, prejudged an

activity and a large heterogeneous group based on the actions of a very small number of people—some of whom behaved with active disregard of federal policies and some of whom behaved with perfectly commendable intentions. Creating a ban to disallow an activity that rangers do not fully understand or that they simply dislike, an activity that makes them afraid that rules *might* be broken in the future, is antithetical to upholding the guarantee that citizens are presumed innocent until proven guilty and is antithetical to maintaining a healthy context for a participatory democracy.

I am not suggesting that all constraints are inappropriate. Just as I understand the aptness of excluding caches at historical and archeological sites, I see the wisdom in not leaving caches in places where unattended packages are likely to make some people particularly fearful. Jeremy Irish and the others who maintain the primary geocaching Website share that concern, and so they provide a list of places where one ought not put a cache. In addition to NPS lands, the prohibited locations are government buildings, military installations, airports, dams, active railbeds, and highway bridges.[31] Placing caches in such places is unwise because doing so would significantly increase social anxiety, fear, and confusion about the status of unattended objects. Were a non-geocacher to spot an odd package in a threat-sensitive site, he or she—and the bomb squad who would be (and, in fact, several times has been) called—would experience unnecessary stress. In sharp contrast, the reduction in risk and fear that the NPS regulation makes plausible is negligible, while the perceived loss of opportunity to enjoy a common good is great.

Providing citizens with a sense of safety without depriving them of personal liberty is a central challenge facing the government, but not the central challenge facing the National Park Service whose mandate (as noted earlier) is to seek a balance between the present desires of millions of visitors to enjoy the parks in environmentally responsible ways and the desires of future visitors to have well-conserved parks they can appreciate. Due to decreased support for the environment through federal policy and funding, that mandate becomes more and more difficult to honor. In 2000, when George W. Bush first ran for president, he promised to "fully fund" the Land and Water Conservation Fund, a promise that pleased the bipartisan National Parks Conservation Association (NPCA). But, in 2003, the same organization issued a report card assessing Bush's park stewardship and gave him a D-minus. "The administration is not doing the job they need to do to fully protect, to fully fund, to fully improve our national parks," said association president Tom Kiernan.[32] In fact, as the executive

director of the Sierra Club, Carl Pope, points out, "Bush's operating budgets for the parks actually fell by a third—$600 million short of what was needed—resulting in the loss of one-third of the visitor education activities at Death Valley and in Yellowstone turning away 60 percent of the school groups that sought to use the park's educational facilities."[33] The financial situation has not improved for the NPS. In July 2004, responding to Secretary of the Interior Gale Norton's positive reports on the state of the national parks, Tom Martin, the executive vice president of the NPCA, observed that, "out of the 388 park sites, 241 parks will have less money under the administration's proposed budget for fiscal year 2005 than they did last year, impacting visitor services and exacerbating the backlog of deferred maintenance needs."[34] Such underfunding is leading to readily observable and environmentally serious consequences. For instance, although "federal laws mandate that national parks should have the cleanest air in America," the EPA included quite a few national parks—notably Acadia, Great Smoky Mountains, Joshua Tree, Rocky Mountain, Shenandoah, and Yosemite—on a June 2004 list of areas with unhealthy levels of ozone pollution.[35]

Overwhelmed by such circumstances, parks officials might have felt they had little energy or time to learn about the new modes of engaging the environment that geocaching creates. Banning the game might have seemed like an expedient solution to park officials burdened with many challenges; but such decision-making strategies don't promote democracy, and it is to Keener's credit that the policy is being revisited.

PLAYING AS A COMMON GOOD

Ironically, the federal policy banning geocaching reveals attitudes counter not only to the nation's own founding principles, but also to the disposition of the game itself. I've noted that geocaching involves individuals mediating between the Web and the world, with the players using technologies that were developed for the military in a distinctly non-militaristic way. The NPS policy, prohibiting the game on 84 million acres of public land, also makes evident a fear of strangers and sense of imperilment that shape much public discourse in this new millennium, emphasizing mistrust, heightened caution, and preemption as appropriate ways of interacting with other people. This discourse and many of the emerging policies urge or require that Americans acquiesce rights to privacy and ease of mobility for the sake of security. In startling contrast, geocachers employ military surveillance

satellite technology to navigate (often alone) in unfamiliar spaces where they take and leave small objects. Often, they establish relationships—both on-line and in-person—with people whom they know initially only by a screen-name. Rather than remain immobilized, geocachers concertedly move about in the world and make available, on their own terms, as much or as little information about themselves and their corporeal identities as they wish to share.

Because such behavior runs counter to the way Americans are urged to act right now, I have not been surprised when people ask me such questions as "Aren't you scared to do this alone?" or "What's the worst thing you ever found in a cache?" or "Do people ever post coordinates but not put a cache there, just to be mean?" Such questions presume some lack of trust in the motives and behavior of others. While I am neither so idealistic nor so insulated as to think distrust is never appropriate, my experiences with geocaching offer a powerful counterpoint to the prevailing vision of danger lurking around every corner. Of the caches I have visited, relatively few have subsequently been archived because they were stolen or destroyed; more succumb to weather than to human wiles. No one has sent me hostile or otherwise inappropriate e-mail. A very high proportion of the disposable cameras I leave in caches (with a return mailing envelope) have been returned to me, a process that typically takes about a year, and no one has ever sent anything untoward in these envelopes.

Thus, while geocachers are indeed behaving in an extraordinarily trusting fashion (at precisely the moment that the government is advocating, even mandating, mistrust), their confidence in one another seems well-placed. Moreover, the game and the emerging subculture require such trust. Geocachers risk disappointment, at least, and serious danger, at most, by walking to coordinates left by strangers on a Website simply in order to find bottles of bubbles, or miniature Barbie dolls, or Mardi Gras beads, or the answer to a question. Yet thousands of people do so each week, many of them parents with enthusiastic young children in tow.

Attributing their willingness to trust one another to idealism or naïveté would be amiss. In 1995, drawing on two decades of annual studies by the General Social Survey, Robert Putnam argued that America is becoming less civically engaged and less trusting; the overall level of trust in America had dropped by nearly one-third since 1972. Moreover, "after controlling for such characteristics as education, age, income, work status, and race," he showed that "citizens of the nation's twelve largest metropolitan areas (particularly their central cities but also their suburbs) are roughly ten percent less

trusting and report ten to twenty percent fewer group memberships than residents of other cities and towns (and their suburbs)."[36] Such a decline seemed momentarily reversed in the immediate wake of September 11, 2001, only to be heightened thereafter under Homeland Security.

While lamentable, the new waning in civic trust is hardly a surprise. Langdon Winner notes in "Complexity, Trust and Terror" that, "in free, democratic societies . . . ordinary people have managed their relationship to vulnerability" by embracing "trust, holding on to the reasonable expectation that key technologies will always work reliably and not break down." In contrast, he says, totalitarian societies tend to install "vast systems of policing and surveillance," and "an inevitable consequence is the destruction of civil freedom." Winner notes that, since 9/11, Americans have felt less confident that key technologies will work reliably; both government officials and average citizens express concern about our electric power grid and our water supply becoming terrorist targets, for example. Moreover, and more worrisome, Winner points out that, in order to reduce our vulnerability, the government has been relying more and more on policing and surveillance, on tactics he calls "muscular sociotechnical fixes." At both the policy level and the personal level, these contribute to "a rapid shift from trust to mistrust," as is evidenced by the facts that "Americans are restricting freedom of travel, limiting access to information, and narrowing the boundaries of political speech. . .we are modifying social life in ways that define people as suspects rather than citizens."[37] Nonetheless, people continue to geocache; indeed, thousands and thousands of people do so each day. In at least this portion of their lives, players are rejecting the discourse of fear and the mistrust of others central to it and are, instead, developing new ways to promote trust and extended community.

The geocaching version of trust is made easier by some of the specific regulating mechanisms built into the game. People alert one another if a cache contains inappropriate items or is in a place that is off-limits—just as they alert one another if the difficulty level promised seems off. In addition, the process itself makes hunting for a cache feel fairly safe. When I read about a specific cache, I note not only the geographical coordinates, but also the entries of those who have visited that site. I know if the coordinates are accurate, whether the cache was easy to find, whether the locale was pleasing. I am not relying on one anonymous stranger for my data, but on a whole set of others who, though also strangers, provide corroborating accounts. I am trusting in a community and its processes. The anonymity and lack of a temporal framework also, perhaps paradoxically, make the game seem safe.

No one knows precisely who will hunt for which cache at what time. A cache may be unvisited for weeks or even months; or it may be visited by several parties who arrive in such close succession that they meet one another. This uncertainty about who will show up, and when, makes the notion that someone might be there, waiting for the chance to cause harm, unlikely. This kind of trust—in strangers who are part of a social network, in the likelihood that reciprocity will occur, in the safety that an unknowable timeframe adds—is what sociologists call "thin trust." Robert Putnam explains that "thin trust is even more useful than thick trust [which is based on enduring, personal relationships], because it extends the radius of trust beyond the roster of people whom we can know personally."[38]

I suggest, though, that geocachers are not just thinly trusting in a process; they are actively resisting the contemporary culture of fear. That so many caches are in remote areas is evidence of that willingness to trust, as is the frequency with which geocachers share intimate aspects of their lives in their forums (a frankness evident on many Internet chat sites). Their trust is not limited to the relative anonymity and safety afforded by on-line conversation, though: local geocaching clubs, groups who meet to geocache together and to participate in Cache In, Trash Out (CITO) events, are proliferating. And, lastly, one of the newer kinds of geocaches, Webcam caches, also suggests that players are consciously engaging the culture of fear. On city streets, cameras that record the actions of passersby and load those images to the Web are now common. Both in Europe, where the cameras have been in use for a long time, and increasingly in urban areas in the U.S., people are designating Webcam caches. These caches do not have a box of toys or a logbook; instead, they require a pair of players to collaborate to make a picture. One player goes to the posted coordinates and stands before the surveillance camera; the other waits at a computer that has an Internet connection. When the first player finds the camera, she notifies her partner to capture the video image of her standing on the street (likely contacting the partner via cellphone or pager, another pair of increasingly ubiquitous technologies). To log this visit on the geocaching Website, the duo sends the image to the person who designated the location as a cache. This use of GPS and Web cameras in geocaching is potentially subversive, as it makes individuals more aware of an omnipresent technology of surveillance while providing ways to use that technology in playful, unanticipated ways. A mode of surveillance meant to cause people to self-censor, panopticon-style, and to remind us to feel threatened and cautious, is eliciting opposite responses.

While geocachers may not form a countercultural walking movement of the sort Rebecca Solnit describes and desires (for they are using augmented bodies), they are creating a countercultural movement by enthusiastically walking, as well as by using dominating technologies for social and whimsical aims, by trusting one another, and by trusting that unattended packages are likely to hold a logbook and toys and not a bomb. Geocachers are adding to the store of "social capital," as Putnam calls it— behaving in ways that increase social cohesiveness, interpersonal trust, and community. In 2004, in a display of impressive trust in the emerging geocaching community, one participant proposed a "geo-hosteling" movement: geocachers who are willing to share their yards (for a tent) or a spare bed in their homes could add themselves to a national or even a global registry. That way, geocachers could travel more inexpensively to new areas and cache sites and could meet kindred folks. The discussion forum about this idea has far more postings indicating that people think it a fine and workable idea than messages indicating hesitation. And even the majority of nay-sayers qualify their reluctance with comments such as "if I were still single I'd participate" or "if I were younger I'd do this."

E-COMMUNITY IRL

Like Solnit, Putnum dates the decline in a sense of community to the 1970s, seeing the sprawl of suburbs and the rise in driving times as major factors. In *Bowling Alone*, he adds that relying on television as one's chief entertainment is not simply another factor in reducing civic-mindedness; it is "the single most consistent predictor" of civic disengagement.[39] Recognizing that computers and the Internet have been the next development in mediated communication, Putnam is attentive to the societal and interpersonal roles they are playing and will continue to play. Sensibly, he suggests that the Internet both contributes to and adversely affects social capital and community engagement.

One way the Internet can enhance community is by creating environments where people with kindred interests who do not live near one another can "convene." Internet chat groups on subjects ranging from the scholarly to the emotionally sensitive, from the political to the whimsical, flood the bandwidth with a constant stream of conversation. These chat groups tend to focus somewhat narrowly on their shared interest—which is both useful in consolidating bonds and troubling in not leaving room for extending the parameters of the conversations or the contact. Still, computer scientist Paul Resnick has optimistically pointed out that what is likely to evolve is neither a monolithic

"cybercommunity" nor a set of absolutely discrete "cyberghettos," but rather a host of "cyberclubs" with overlapping memberships.[40] Like nodes in a data network, members will be nexus points in linked social networks.

Just as geocaching makes evident some ways that people obliquely address contemporary tensions about becoming posthuman due to our reliance on computers, it also illuminates ways in which we are indirectly testing out new forms of community made possible by computers. A key point is that geocaching's community is unique: it relies equivalently on the physical and the virtual; it depends on trust and reciprocity in the ways that earlier forms of community did—but it has developed a form of indirect reciprocity that is unusual; and it relies on "reputation systems," as do traditional communities, while still allowing for anonymity.

From my own experience, I know that geocaching offers a way to consolidate existing relationships—giving family members and friends an interesting and healthy activity to do together. Moreover, the pictures from the cameras I leave at caches illustrate that many others also cache in groups of family or friends. Regularly, the photographs include two, three, and (in one case) four generations of a family caching together. Almost as often, they show pairs of adults. Many pictures show individuals caching alone, though often the presence of a second person is implied by the distance of the person in the picture from the camera. And still others cache as part of scouting activities or school programs. This anecdotal assessment is reinforced by the survey that Ingrid Schneider conducted of geocachers in Minnesota: of the 133 respondents, 48.1 percent reported geocaching with their families, another 19 percent with family and friends, and 24.8 percent reported caching alone.[41]

My photographs and Schneider's survey do not have a way of taking into account the tremendous increase in the number of geocaching clubs and events. Through such groups and their activities, the geocaching community routinely moves off-line and into the physical world. Discussion threads frequently include anecdotes about new relationships that the game has fostered. I've even seen stories of marriage proposals that involved geocaching; one man required his beloved to geocache in order to find the ring! Apparently, the game creates more contexts for consolidating existing bonds and creating new interpersonal connections than I'd imagined.

Geocaching is hardly alone in enabling relationships that begin on-line to enter the physical world. But, unlike on-line dating services or support groups, its aim is not to do so. These friendships

and this new form of community emerge because of three crucial conditions built into the game: a need for trust, an expectation of reciprocity, and a connection to land and places. I've written at length about the importance of place, about the desire to spend time in interesting settings that is central to geocaching. And I've discussed trust, which is extremely well-maintained, especially given that players use screen names (which permit anonymity). Trust is maintained through the group's self-regulation. Players affirm that they are abiding by geocaching guidelines posted on the Website when they hide their caches—and at that point a volunteer checks that the place is appropriate and that the owner can be responsible for taking care of the cache. After this step, geocachers self-police, a fitting trait for this independent, democratic society. If a cache's coordinates are off, visitors let the owner know and post new ones to the Website. If the cache seems to have disappeared, similar Weblogs alert the owner that she or he needs to check on it.

Another component to trust is reputation. In real life, we trust others in large part because doing so in the past worked out favorably. We have either personal evidence or the reports of others that someone is reliable and responsible. Evidence from others is expressed as reputation. And, in geocaching, reputation is easily broadcast to the entire world. If one creates geocaches that are especially pleasing, then the Weblogs for those caches will include compliments about the location in general, or the arduousness of the walk to the locale, or the cleverness of the hiding place, or even the cache's contents. In that way, a reputation builds, and geocachers take care to visit caches by people who have demonstrated unusual craft. Similarly, geocachers who are the first to find a cache are often accorded grudging praise by those who subsequently find it. Near my home, someone named WaldenRun often finds caches first. Although I've seen the name on so many cache entries that I've begun thinking of this person familiarly, I actually don't know if WaldenRun is a man or a woman. I know only of prowess demonstrated and the admiration others evince. But the significant corollary is that WaldenRun's overall reputation is enhanced by this ability to find caches quickly. Players express great interest in finding caches that WaldenRun has placed because he or she exhibits skillful gamesmanship.

Most geocachers seek many more caches than they hide; a much smaller proportion of players hide more caches than they seek. In Schneider's survey, the average number of caches hidden was only 3.7 per person, while the average number found was 74.2.[42] Even with these skewed numbers, a

significant form of reciprocal engagement occurs. Sociologists note that reciprocity enhances conventional communities because it allows people to expect help at some later date. To work as a community-consolidating behavior, the reciprocity must extend over a large group. One year, when I lived in Maine, I learned the importance of such extended reciprocity when I had the bad luck to get my car stuck in ditches half a dozen times. Only once did I need a tow truck; the rest of the times passersby helped me out, always refusing payment. Several times I was told by the good Samaritan that he'd want someone to do the same for his wife in similar circumstances. My experiences make clear one reason why geographical boundedness has tended to be a central feature of successful communities: reciprocity across a group works best when people have reason to assume the people who will be there at some future point (and, hence, be in a position to give aid) will share the notion that such helpfulness is fitting.

In geocaching, reciprocity extends across the group in a similar fashion. I am not limited to searching only for as many caches as I have hidden. All players can hunt for all caches; so players become a vast network working for mutual enjoyment. Such group level reciprocity was implicitly built into the take-a-trinket, leave-a-trinket exchange system at the outset. Out of that rule have emerged varied notions about the exchange of objects: some players take nothing and leave nothing (TNLN is the acronym for this in the United States; equivalent acronyms appear in other languages as well, suggesting that this ethos is as widespread as the game); such gamers are content to have had the walk and found the cache. Other players create caches that are themed—and ask players to keep exchanges consistent with that theme; they are interested in the objects as clever self-expression, in part. Still other players make a point of leaving more exotic or delightful objects than they take. Most of the players I know are adults, and they tend to leave more than they find—believing that the objects are primarily for the pleasure of children, and that the walk, or the time with family or peaceably alone, or the hunt is the intended treasure for adults. My young niece and nephew are thrilled by the objects they are able to take home from a cache, but also delight in leaving good toys for the next person; geocaching provides simple, fun reinforcement for family lessons about the value of sharing.

In fact, like true gift-giving, geocaching exchanges are not predicated on expecting that the receiver will then offer the giver something. The exchange permits selfless generosity. Extended not

toward those whom one knows, but literally toward others whom one will likely never know, such generosity is increasingly unusual in the contemporary world. Like charity, it aids a community by making something available for another; but, unlike charity, it is mutual at the material level as well as at the emotional level. By receiving as well as giving, players remain in an egalitarian position in relation to one another. At the level of the geocache as an object, this egalitarianism was especially clear to me when I visited a baby shower cache near my in-laws' home in St. Louis. The mother-to-be enjoyed geocaching, so a friend created this geocache to surprise her. It could easily have been an occasion for one-way generosity; the creator of the cache, however, filled it with "shower favors" for others to take, reinforcing the bi-directionality that is important to community (see page 136). Far more important than the toys, though, is that geocachers give others an experience: an invitation to discover a place, an opportunity to solve puzzles, a chance to have some fun. Those who give the experience may not ever be given a corresponding gift from those who visit their cache. But the overall bi-directionality is maintained because so many people participate; each day, the pool of potential pleasures grows.

In emphasizing the uniqueness of this form of community, I wish to suggest two possibilities. First, it may be an intermediary model, a melding of past ideas of how to form a community with newly emerging ideas about how virtual communities can grow and thrive. If so, this model may wane as computer-mediated relationships become more and more dominant. Second, the model of community that geocaching provides may suggest ways to maintain links to the land and to physical interaction, even as we more fully incorporate virtual technologies into our lives. I advocate the latter. Historically, among the most successful, most enduring communities are those comprised of people living in a proximate relationship to one another with a connection to a piece of land or a place. While nomadic groups and diasporic communities continue to exist, even the latter typically maintain a mental and emotional connection to a location. Geocaching offers one model for citizens in a globalized world to develop a form of coherent community that takes into account an appreciation of land without the risks associated with a regionalist or nationalist link to place. It is not to New England or to the United States that I express a connection as a geocacher; it is to the physical world itself and to the ways that a link to the land can promote a healthier life at individual, social, and environmental levels.

ALL THAT AND GREEN SILLY PUTTY, TOO

I have sought to clarify a few of the ways in which geocaching is both a nexus for current cultural anxieties and an interesting, if oblique, mode of engaging those anxieties. Geocachers do not assert that they hunt for small toys in order to address cultural tensions or to imagine new forms of humanity and community. But some people are so aware of the benefits they've gained through playing the game that they contribute personal narratives to a geocaching discussion thread entitled, "How geocaching helped me to actually get a life, dispelling inaccurate myths." The thread includes accounts—some intimate and serious—about ways in which the individual's life is enhanced by the activity, focus, and community that geocaching affords. Many Internet communities include intimate disclosures, of course; the safety that a screen name provides frequently allows people a freedom they do not feel in real life.[43] However, a difference here is that the game itself is adding to the individual's ability to act and feel healthier, as well as to speak. While discussion forums for those who are ill and for their families, for instance, provide an emotionally therapeutic outlet, they do not create the conditions for recovery. Geocaching does. To be sure, walking *without* hunting for geocaches would accomplish many of the goods that individuals note, but it would not promote all of them. And frequently players note that they did not walk much (or as much) prior to playing; one geocacher from Texas described going on a diet and beginning an exercise regimen so she'd be able to join a companion on more challenging hunts. The game gave her a health-promoting opportunity, but one that was not being presented as therapeutic.

That ability to make a space for new activity that is both personally and socially interesting and useful is precisely the reason geocaching merits attention. It allows us to glimpse new human-machine interfaces, to understand the ways that individuals in a culture which is both privatized and fearful are striving to create situations that promote trust, and to define modes of community that are forward-looking and satisfying. Geocaching allows us to do so not in a seminar room or in a simulations lab, but in our communities, our parks, and our last bits of "wilderness"—as we live the models, walk the walk, and gleefully play with the lime green silly putty that a stranger has generously left for us to discover.[44]

Notes

1. Office of the Press Secretary, The White House, "Statement by the President Regarding the United States' Decision to Stop Degrading Global Positioning System Accuracy," May 1, 2000.

2. In fall of 2005, there were 400,000 active accounts on *www.geocaching*.com and another 200,000 accounts that were no longer active. Active accounts are those of individuals who are presently recording hides and finds of caches. Because many of those accounts represent families or other groups of people who cache together, he arrived at the larger figure as an estimate. I believe the figure is considerably higher. My account represents two people. I have, however, brought at least seventy other people on geocaching jaunts.

3. Environmental Protection Agency, "Indoor Air Quality," available at *http://www.epa.gov/region08/air/iaq/other.html* (May 14, 2005).

4. Ingrid E. Schneider, Director of Tourism Center, University of Minnesota, with Todd Powell. "Geocachers and Geocaching in Minnesota: Profiles, preferences, and management ideas," working paper, December 2003.

5. This quote and the one above are from Peter H. Kahn, Jr. *The Human Relationship with Nature: Development and Culture* (Cambridge: The MIT Press, 1999), 10.

6. US Census Bureau, *US Census 2000, brief,* "1990 to 2000 Population Change and Distribution," available at *http://www.census.gov/prod/2001pubs/c2kbr01-2.pdf.*

7. Kahn, *The Human Relationship,* 111.

8. Rebecca Solnit, *Wanderlust: A History of Walking* (New York: Penguin, 2001), 249.

9. Philip J. Longman, "American Gridlock," *U.S. News & World Report,* (May 28, 2001): 16–21.

10. David Schrank and Tim Lomax, Texas Transportation Institute, The Texas A&M University System, *2004 Urban Mobility Study.* Available at *http://mobility.tamu.edu/ums/report/.*

11. John G. Mitchell, "The American Dream—Urban Sprawl." *National Geographic* (July 2001): 48.

12. Solnit, *Wanderlust,* 258.

13. Barbara A. McCann and Reid Ewing, "Measuring the Effects of Sprawl: A National Analysis of Physical Activity, Obesity, and Chronic Disease," *Smart Growth America,* September 2003, 19. Available at *http://www.rwjf.org/publications/publicationsPdfs/Health&SprawlFinal.pdf.*

14. Ibid., 23.

15. Ibid., 267.

16. Chris Granstrom, "They Live and Breathe Letterboxing," *Smithsonian Magazine* (April 1998, vol. 28, no. 1): 82–90.

17. N. Katherine Hayles, *How We Became Posthuman: Virtual Bodies in Cybernetics, Literature, and Informatics* (Chicago: University of Chicago Press, 1999); Francis Fukuyama, *Our Posthuman Future: Consequences of the Biotechnology Revolution* (New York: Farrar, Straus, and Giroux, 2002). Many of these issues are also addressed in *The Cyborg Handbook*, ed. Chris Hables Gray (New York: Routledge, 1995).

18. Hayles, *Became Posthuman*, 2–3.

19. In Hal Foster, *The Return of the Real* (Cambridge: The MIT Press, 1996), 220.

20. Hayles, *Became Posthuman*, 48.

21. Foster, *The Return*, 221.

22. Marshall McLuhan, *Understanding Media: The Extensions of Man*, (New York: Signet Books, 1964), 235.

23. Ibid., 244.

24. Roger Caillois, *Man, Play, and Games*, Trans. by Meyer Barash, (New York: The Free Press, 1961), 9–10. The French edition was originally published in 1958.

25. *http://www.clemetparks.com/recreation/geocaching/index.asp*, May 4, 2005.

26. This acreage is based on 2003 data, as of this writing the most recent date for available information.

27. Section 8.2.2 of the *2001 NPS Management Policies*, available at *http://www.nps.gov/refdesk/mp*.

28. United States Department of the Interior, Bureau of Land Management, Instruction Memorandum No. 2003-182, June 2, 2003. Available at: *http://www.blm.gov/nhp/efoia/wo/fy03/im2003-182.htm*.

29. Marcia Keener, "NPS geocaching policy Statement" (Washington D.C.: NPS Office of Policy, October 10, 2002).

30. Idem. These direct quotes, as well as the other observations I share in this paragraph, come from telephone conversations with the author, July 12 and July 13, 2004.

31. Given this prohibition, and especially given the reasons for it, it seems almost painfully ironic that the only geocache currently in Afghanistan is on a military base housing American soldiers, and that most of the geocaches in Iraq are also in areas under American military control. Moreover, the people who have found these caches and logged the finds to the Website have been American soldiers in active service in those countries.

32. This quote is repeated often. One source is a "Committee on Resources" document that is available at *http://resourcescommittee.house.gov/Press/releases/2003/0807secret.htm*.

33. Carl Pope and Phil Rauber, *Strategic Ignorance: Why the Bush Administration is Recklessly Destroying a Century of Environmental Progress* (San Francisco: Sierra Club Books, 2004).

34. National Parks Conservation Association Press release, July 8, 2004, Available at http://www.npca.org/media%5Fcenter/PressReleaseDetail.asp?1d=186.

35. National Parks Conservation Association Press release, June 24, 2004, Available at *http://www.npca.org/media%5Fcenter/PressReleaseDetail.asp?id=185.*

36. Robert Putnam, *Bowling Alone: The Collapse and Revival of American Community* (New York: Simon & Schuster, 1995).

37. Winner, Langdon. "Complexity, Trust and Terror." *Tech Knowledge Review*, 3.1 (October 22, 2002). Available at *222.netfuture.org/2002/Oct2202_137.html.*

38. Putnam, *Bowling Alone*, 136.

39. Putnam, *Bowling Alone*, 231.

40. As quoted in Putnam, *Bowling Alone*, 178.

41. Schneider and Powell, "Geocachers," x.

42. Schneider and Powell.

43. In Howard Rheingold's *The Virtual Community*, he noted with surprise the great intimacy he felt for people whom he only knew online. Since that book appeared in 1994, the proliferation of chatrooms and other vehicles for establishing online relationships has made clear that many, many people find such contact satisfying.

44. Updates about changes in the National Park Service's geocaching policies are available on the Website for this project: *www.localtreasures.org.*

The main geocaching Website, *www.geocaching.com*, includes excellent advice for getting started. In addition, several books are devoted to the practical aspects of this pastime, including suggestions about not only how to hide and seek a cache, but also on outdoor safety and related issues. If *Local Treasures* has inspired you to set off on a geocaching adventure, however, and you're eager to begin right away, then here are some absolutely essential things to keep in mind.

1. *You need a GPS receiver (GPSr) and the coordinates for a geocache.*
These receivers (which most people simply call GPS's, rather than the more accurate GPSr) range widely in price, but begin at approximately $100 for one that will work well for geocaching. They are available at sporting goods and outdoor recreation equipment stores. At present, the ones in ordinary cell phones are not useful for playing—though I won't be surprised if this situation changes soon.

GPSr users debate the merits of different brands and models, and Marc Clemens reviewed several in a useful article entitled "A Walk in the Woods" in *Scientific American* (February 2004). As geocaching has increased in popularity, the staffs at outdoor equipment stores have become excellent resources for information about the comparative merits of different GPS receivers with respect to the needs of geocachers.

All that said, let me tell you what I use and why. My current GPSr is a Garmin 60C. While there are many less expensive models that are absolutely sufficient for geocaching, the 60C has a few additional features I find very valuable. It can display maps in color (which makes it easier to distinguish roads from elevation lines from rivers), and it has enough memory that one can load detailed topographical maps and point of interest maps for large areas. Those added features may not matter if you expect to geocache once a month or so, but avid geocachers often venture far from home, and

many incorporate geocaching into their other travel plans. In those cases, detailed maps are incredibly handy. Whatever model you select, know that a GPSr is designed straightforwardly and, thus, is easy to learn to use.

2. *The coordinates for caches are found on the geocaching Website.*
While other Websites list caches, the one run by Groundspeak that I've referred to throughout this book, at *www.geocaching.com*, is the most comprehensive. By keying in your zip code, you can get a list of the caches within 100 miles of home.

3. *Find a few caches in your home area before hiding any.*
Doing so will give you ideas not only for placing a cache in ways that do not harm the environment, but also for choosing the sort of container that is advisable in your region and the ways that people in your area interpret the difficulty ratings. Often caches are covered with previously fallen branches, or nestled into rockpiles, because they need to be hidden without digging or destroying plants. In areas where winter includes extremely cold weather, for instance, one does well to avoid hard plastic containers (since they crack) and pens (the ink leaks when they freeze and then thaw).

I was surprised to discover that the interpretation of the ratings varies by region of the country; for example, what people describe as a short walk in the Southwest tends to be longer than a short walk in the Midwest. Geocaching near home also eliminates the challenge of figuring out how to get to the general vicinity of the cache; in an unfamiliar area, navigating one-way streets or getting to the right side of a river can be harder than finding the cache once you've reached the park or conservancy area.

4. *To maximize your enjoyment, note not only what kind of cache each is, but also the difficulty ratings.*
Cache types have proliferated in the last few years, but the first attribute to note is whether the cache is a real container or a virtual cache. While there are other variants—such as Webcam caches, multi-caches, event caches, and locationless caches—the majority of caches are small containers or virtual caches. If exchanging objects is likely to be an especially fun part of geocaching to you (or if you are bringing youngsters who are excited about the secret treasure aspect), then be sure the

cache is physical *and* that it contains objects. Microcaches, while physical, are often film canisters that hold only a strip of paper on which you can record your visit.

Paying attention to the difficulty of both the terrain and the hiding place allows you to choose a short, easy meander that ends with a diabolically well-hidden cache, if that appeals, or a long, more strenuous hike, if that would be more fun. In addition, reading through the logs other geocachers have posted to the Website lets you both confirm that the cache has been found recently and find out a little more about it through the reactions others have had. Often, visitors will note whether the cache is easy to find, whether the hike is appealing, and so on. Use that information to help you select places appropriate to your agility, stamina, and interests.

Once you have a working GPS and the coordinates for a cache location, you're nearly ready to go.

5. *Consider bringing a printout of the Webpage describing the cache; it includes an encrypted clue that you can decode if you get stuck. And always keep in mind general outdoor safety guidelines.*
Regarding safety, have a map of the area, wear appropriate shoes, bring ample water, tell someone where you are going, and give yourself enough daylight for a leisurely round trip plus a little extra in case the cache is hard to locate.

6. *Lastly, if you are going to a traditional cache, rather than a virtual one, consider bringing an object to exchange.*
Typical cache objects are inexpensive items that might be fun for children of all ages (bubbles, silly putty, playing cards, origami paper) or useful for hikers (maps, carabiners, gear repair kits). The only constraints are that one be sensible (no food, nothing untoward or dangerous) and that the item be small enough to fit—along with other items—in a modestly-sized container.

Happy caching! Perhaps we'll meet on the trails.

Cache: pronounced "cash"; a hidden container filled with a logbook, pencil, and (often) objects. Caches were often used by explorers, miners, hunters, and others to hide foodstuffs and other items for emergencies. Appalachian Trail hikers and other trekkers still use caches for similar reasons.

CITO—Cache In, Trash Out: an acronym used to encourage geocachers to clean up litter while they cache. Often, CITO events are held around Earth Day (April 22).

Dithering: the introduction of digital noise. This is the process that the U.S. Department of Defense used to reduce the accuracy of civilian GPS receivers (GPSr) under Select Availability.

Event cache: a gathering arranged by geocachers and open to all geocachers. Most often, they are social events that involve hunting for new caches created for that event, trading travel bugs, having contests and the like, and cleaning up a locale (such as CITO). Some are sponsored by local geocaching clubs or civic organizations; others are organized by individuals.

FTF (or *TFTF*)—*(The) First to Find:* an acronym used to indicate that player who was first to find a new cache. Often, cache owners put in a special prize for the FTF cacher.

Game space: the circumscribed area within which a game takes place. For instance, the game space for a temporary bocce court might be one's whole backyard for a duration of two hours. Among the most relevant aspects of game space are that it is an overlay onto reality (the backyard is still the backyard) and that, historically, we have thought of a game space as "pure" for the duration of play—that is, it could not be used for another purpose during the game. I cannot play badminton in the yard while it is functioning as a bocce court. Geocaching offers an importantly different relation to game space.

Geocaching: from "geo" for geography and "caching" for the process of hiding a cache; a high-tech treasure-hunting game invented in May 2000. Players use a handheld GPS receiver (GPSr) to determine locations of containers, which hold a logbook and often small toys, that have been placed on public lands by other players. After signing the log, many players swap a toy they've brought with them for a toy in the cache. Geocaching has no entrance fees or dues. Its few rules focus on preserving the environment, protecting people and animals that may happen upon a cache, and creating a community of fellow geocachers.

GPS (Global Positioning System): a satellite-based navigation system which employs satellites placed into orbit by the U.S. Department of Defense. Although GPS was originally intended for military applications, the federal government made the system available for civilian use in the 1980s and widened that availability on May 1, 2000. As of this writing, more than two dozen GPS satellites circle Earth twice a day in precise orbits, transmitting high-frequency radio signals. Essentially, the GPS receiver (GPSr) compares the time a signal was transmitted by satellite to the time it was received. The time difference tells the GPS receiver how far away the satellites are. By triangulating the information from at least four satellites, the GPS receiver can calculate its exact location.

GPSr—Global Positioning System receiver: a device which calculates latitude, longitude, and altitude by triangulating GPS satellite data received from at least four satellites orbiting Earth. The margin of error for the handheld devices currently available to civilians is just a few yards.

Groundspeak: the company which runs the largest geocaching Website (*www.geocaching.com*).

Latitude: a north/south measurement of position perpendicular to Earth's polar axis.

Locationless cache: a relatively unusual form of cache that involves players looking not for a place but for an object that meets certain criteria; also known as a *reverse virtual cache.*

Log: an entry written in the logbook at a cache site or a similar entry on the cache page on the Website describing one's visit to a cache.

Logbook: a notebook at a cache site used by geocachers who find a cache to record an entry. When you read a logbook, some of the shorthand that geocachers use (such as CITO, FTF, TFTF, TNLN,

TNLNSL) may seem as confusing as the encoded clues on the Website. You'll soon find that the language of the game, like the game itself, makes great sense.

Longitude: an east/west measurement of position in relation to the prime meridian (Earth's zero longitude recorded at Greenwich, England), which is an imaginary circle that passes through Earth's north and south poles.

Micro-cache: a very small cache; often a film canister housing only a logbook.

Multi-cache: a cache which requires players to go to several locations to find several components, typically finding clues at each location that allow them to find the next location. Often, players must find the cache components in order, as information about each successive location is only available at one location.

Notebook: see *logbook*.

Reverse virtual cache: see *locationless cache*.

Select Availability (SA): the U.S. federal government's policy of denying non-military users full, accurate access to GPS. On May 1, 2000, the Clinton Administration repealed SA with the hope that doing so would promote industrial and research uses of GPS. Such uses have proliferated. The first documented new use, however, was the game of geocaching.

TFTC—Thanks for the Cache: an acronym often used in a cache's log.

TNLN (or *TNLNSL*)—*Took Nothing, Left Nothing (Signed Log):* an acronym used by geocachers who do not exchange objects, but simply want to record having found the cache.

Traditional cache: a container that holds a logbook, writing implement, and some objects for exchanging. Though other cache types are proliferating as the game grows, traditional caches remain the default.

Travel bug: in standard English, this refers to a hankering to travel, a yearning to get on the road, to be somewhere new, a wanderlust; in "geocachese," it is a small object to which is attached a dogtag with a serial number. The object has a "travel goal," and it is carried from cache to cache by players

who help it attain that goal. For example, a geography class might set a travel bug on its way, asking players who find it to carry it to caches in all fifty U.S. states. Or a baseball fan might create a travel bug that she hopes will visit caches in all American League and National League cities. Travel bugs often act as educational or vicarious voyagers.

Virtual cache: a cache site at which there is no container with a logbook. The cache involves solving riddles (or answering questions) at or about the cache location and then e-mailing those answers to the cache owner.

Webcam cache: a cache site where players are required to find and be photographed by a Webcam (surveillance camera) that is in public. That photograph serves as proof that one found the cache. Such caches are more widespread in Europe, where urban surveillance cameras have been in use for longer than they have in the U.S. As these cameras have begun to proliferate in the U.S., however, so have Webcam caches.

While many people whom I know have helped make this book possible, my first thanks go to people whom, for the most part, I've never met—to the hundreds of thousands of geocachers who share their appreciation of places, their creativity, and their time to make the activity possible. A special thanks to Jeremy Irish and the other folks at Groundspeak, who maintain www.geocaching.com, the primary Website through which the game is coordinated. Thank you to the hundreds of geocachers who have found the disposable cameras I've left around the world, and humored a stranger by making a few pictures. Many of the pictures from cameras that withstood their exposure to the elements (sadly, many did not) are on the Website that I maintain for this book, *www.localtreasures.org*.

I extend a special thanks to Barbara Bosworth, for the question that launched a thousand more. In February 2002, she asked me what I thought contemporary photographs about maps might be like. Days later, I heard about geocaching through a story that aired on NPR—and had the sense that the universe was whispering the beginnings of an answer into my ear. Additional thanks go to Frank Gohlke, whose encouragement helped me widen and deepen my explorations of geocaching and of photography, and to Marc Elliott for his care and attention to printing the book's images. Thank you to Dylan Vitone, Lyssa Palu-ay, Sonia Targontsidis, and all of my photographic compatriots at the Massachusetts College of Art for helping me to define and refine what it was I thought I was doing. Thank you to John Holland, Nita Sturiale, Ron Wallace, Donald Burgy, and Amy Robinson for welcoming me into the Nature & Inquiry Artists Group, and for being unceasingly curious about nature and science and about how to express that wonder in artworks.

Thank you to Larry Kelley, who taught me how to use a GPS and who continues to help me remember the importance of exploring. A thousand, thousand thanks to Janet Lipsi for reading all of the stories in their varied incarnations, for accompanying me on a long, surprise-filled geocaching extravaganza, and for a friendship that makes me believe that community is absolutely possible across great geographic distances. Thank you to Gina Rubery for sharing an equally memorable geocaching journey in "the heart of the heart of the country" (as William Gass dubbed it). And thank you to everyone who joined me on shorter jaunts; that goes double to those who came along on quests where we didn't find a cache!

Many thanks to Lauren A. Marcum, Kendall B. McGhee, and Amber K. Lautigar at the Center for American Places, for their interest in, and attention to, every detail of this project, and to Kristine Harmon, for her careful and thoughtful copyediting. Many more thanks to George F. Thompson, president and publisher at the Center, for his steadfast support of this book's publication, and for his judicious suggestions about its organization and design. Special thanks to Groundspeak, Bentley College, and Il Miglior Fabbro for their generous financial support.

Deepest thanks, as always, go to Robert, my most frequent caching companion, my partner in all things.

Margot Anne Kelley was born in 1963 in Worcester, Massachusetts, and she was raised in Clinton, Massachusetts. She received her B.A. in English at the College of the Holy Cross, her M.A. and Ph.D. in English and American literature at Indiana University, and her M.F.A. in media and performing arts at the Massachusetts College of Art. Prior to receiving her M.F.A., she spent a decade as a faculty member in the English Department at Ursinus College, where she served for two years as the director of the Writing Center and two years as an assistant dean of the College. She is the editor of *Gloria Naylor's Early Novels* (Florida, 1999), and her writings have appeared in *Antipodas*, *African American Review*, *Interfaces*, *Modern Drama*, and many anthologies, including *Ethnicity and the American Short Story*. Her photographs and other artworks have appeared in numerous exhibitions and galleries, among them the Berman Museum of Art, the Copley Society of Art, the Photographic Resource Center, and Sea Studio Gallery. Her photographs are included in corporate and private collections, and in the permanent collections of the Portland (Maine) Museum of Art and the Berman Museum of Art. Ms. Kelley resides part of the year in Cambridge, Massachusetts, where she teaches at the Art Institute of Boston, and part of the year in Tenants Harbor, Maine.

Frank Gohlke was born in Wichita Falls, Texas, in 1942, and he was raised in Texas. He attended Davidson College, earned his B.A. in English at the University of Texas in Austin, and completed an M.A. in English literature at Yale University where he studied photography with Paul Caponigro and was encouraged by Walker Evans to make photography his lifework. He has received two National Endowment for the Arts Fellowships, a Bush Foundation Artists' Fellowship, and two John Simon Memorial Foundation Fellowships in Photography. His photographs have been exhibited widely in the United States, Europe, and Japan, including one-person shows at the Amon Carter Museum of Western Art, Art Institute of Chicago, George Eastman House, Museum of Contemporary Photography, and Museum of Modern Art, among others. He is the author of *Landscapes from the Middle of the World* (Friends of Photography and Museum of Contemporary Photography, 1988), *Measure of Emptiness: Grain Elevators in the American Landscape* (Johns Hopkins, in association with the Center for American Places, 1992), and *Mt. St. Helens: Photographs by Frank Gohlke* (Museum of Modern Art, 2005). He teaches photography at Harvard University.

The Center for American Places is a tax-exempt 501(c)(3) nonprofit organization, founded in 1990, whose educational mission is to enhance the public's understanding of, appreciation for, and affection for the natural and built environment. Underpinning this mission is the belief that books provide an indispensible foundation for comprehending and caring for the places where we live, work, and explore. Books live. Books endure. Books make a difference. Books are gifts to civilization.

With offices in Santa Fe, New Mexico, and Staunton, Virginia, Center editors bring to publication as many as thirty books per year under the Center's own imprint or in association with publishing partners. The Center is also engaged in numerous other programs that emphasize the interpretation of place through art, literature, scholarship, exhibitions, and field research. The Center's Cotton Mather Library in Arthur, Nebraska, its Martha A. Strawn Photographic Library in Davidson, North Carolina, and a ten-acre reserve along the Santa Fe River in Florida are available as retreats upon request. The Center is also affiliated with the Rocky Mountain Land Library in Colorado.

The Center strives every day to make a difference through books, research, and education. For more information, please send inquiries to P. O. Box 23225, Santa Fe, NM 87502, U.S.A., or visit the Center's Website (www.americanplaces.org).

ABOUT THE BOOK:

The text for *Local Treasures: Geocaching across America* was set in Cheltenham and Franklin Gothic. The paper is acid-free Chinese Goldeast, 157gsm weight. The four-color separations, printing, and binding were professionally rendered in China.

FOR THE CENTER FOR AMERICAN PLACES:

George F. Thompson, President and Publisher

Amber K. Lautigar, Publishing Liaison and Associate Editor

Kendall B. McGhee and Lauren A. Marcum, Publishing Liaisons and Assistant Editors

Brandy Savarese, Project Advisor

Ernest L. Toney, Jr., Chelsea Miller Goin Intern

Kristine Harmon, Manuscript Editor

Rebecca A. Marks, Publicity and Production Assistant

David Skolkin, Book Designer and Art Director

Dave Keck, of Global Ink, Inc., Production Coordinator

186